The Complete

Digital
Animation
Course

The Complete

Digital Animation Course

Principles, practice, and techniques:
a practical guide for aspiring animators

ANDY WYATT

BARRON'S

778534
WYA

A QUARTO BOOK

First edition for the United States, its territories and dependencies, and Canada published in 2010 by Barron's Educational Series, Inc.

All inquiries should be addressed to:
Barron's Educational Series, Inc.
250 Wireless Boulevard
Hauppauge, NY 11788
www.barronseduc.com

ISBN-13: 978-0-7641-4424-0
ISBN-10: 0-7641-4424-3

Library of Congress Control Number:
2009925592

QUAR.DAC

Conceived, designed, and produced by:
Quarto Publishing plc
The Old Brewery
6 Blundell Street
London
N7 9BH

Senior editor: Liz Dalby
Picture researcher: Sarah Bell
Design assistant: Saffron Stocker
Art director: Caroline Guest
Designer: Karin Skånberg
Creative director: Moira Clinch
Publisher: Paul Carslake

Color separation by Modern Age Repro House Limited
Printed in China by 1010 Printing International Ltd

9 8 7 6 5 4 3 2 1

Contents

Introduction

Animation is defined as the manipulation of images frame by frame which when played as a sequence in fast succession creates the illusion of movement. The word "illusion" is to me the most interesting word in this description, because that is really what anyone creating animation is doing. We are illusionists.

The craft and principles of animation have not changed since the 1930s, but contemporary digital animation techniques now allow artists to create amazing images and sequences that would have been impossible just a few years back, let alone 70 years ago, but in essence animation remains the same. Digital technology is a very useful tool to make the process more streamlined, but it will not make you more creative. That is something you have to learn and nurture. This book showcases how digital technology has affected every aspect of the modern animation production process.

Growth industry

Digital animation is an exciting and growing part of the creative industry, and barely a day will go by when you will not be exposed to some form of animation. The advertising, film and visual effects, TV and games industries are huge patrons of digital animation, but new digital media such as online, mobile phone technology, and portable entertainment devices such as the iPod are new platforms for animation to be screened. Other growth areas include live entertainment, such as animated backdrops at concerts or clubs, animated billboards, and corporate areas such as the medical profession who may use animation in training situations.

This book provides the reader with an overview of the digital animation process, from conception to completion, highlighting the many creative roles within animation production.

As well as thanking my wife Helen for her fantastic help and support (and putting up with me spending so many weekends working on this) I would also like to acknowledge staff and students at University College Falmouth who contributed many of the images used throughout.

Andy Wyatt

About this book

This book introduces students and rookie animators to the digital animation process, from initial conception to completion, focusing on every stage of the production.

See also
Useful related articles are identified.

Assignments
Once you've read about a technique, it's time to use it and see how it works when put into practice.

Articles
Your structured course leads you step-by-step through the key aspects of digital animation. Content is organized into three distinct areas: pre-production, production, and post-production, with an additional section on professional practice.

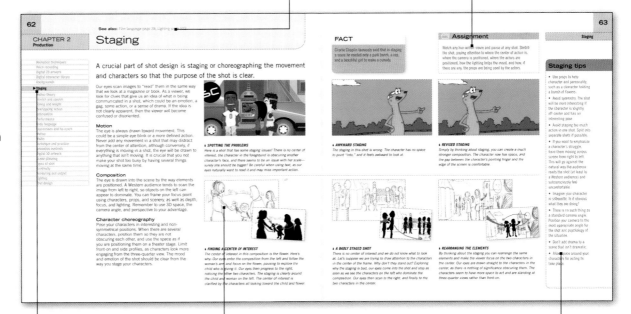

Check out the useful glossary!
There's a helpful glossary on pages 138–140 explaining technical words and terms.

Technique finder
Each technique is listed in the "technique finder," an at-a-glance listing of all the articles in the chapter that lets you place the (highlighted) article in the context of what comes before and what comes after.

Visuals
Real, working images taken from professional animations illustrate the key themes and practices.

Tip panels
Hundreds of tips and facts to help you become a creative professional.

Digital equipment

It is now possible to own some really powerful digital animation tools that just a few years ago were the exclusive domain of professional studios. When setting yourself up as a digital animator there are a number of factors to think about.

Hardware

When considering a computer for digital animation make sure you choose a good graphics card that is capable of rendering high resolution images and plenty of RAM, as some applications will eat up memory just to run. You will also need ample hard disk storage space for your work, which can be on portable drives. You may also want to invest in a large monitor (or even two for a dual setup), which will not only make it easier to view the many open windows, but will be more gentle on your eyes. It makes no difference whether you use a PC or a Mac; most software is available for both platforms.

There are also a few peripheral devices you will find invaluable for digital animation. A graphics tablet such as a WACOM will make digital drawing, color, and design work much easier, and you will also need a scanner to import sketches, designs, textures, and backgrounds, or any physical artwork. A digital camera will also be useful, particularly for collecting textures.

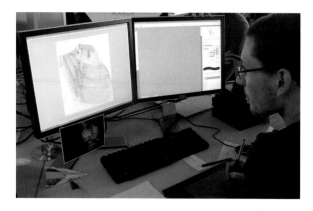

◄ DIGITAL WORKSTATION
A typical digital workstation with dual monitors and a graphics tablet for digital design and drawing.

Software

There are specialist digital applications for every technique of animation available, but these can be put into four main categories:

• Frame-grab software for digitizing live images frame by frame for digital stop-frame animation

• Digital 2D animation programs for "cel" animated cartoon-style animation

• Digital 3D animation packages for modeling, animating, and rendering for 3D CGI (computer-generated images)

• Compositing software that merges together and manipulates layers of animation into a final complex image, often used for visual effects.

Using Flash

Flash is a versatile software package for creating 2D linear or interactive animation to export for TV, web, and mobile platforms. It is primarily a vector-based package, which also supports bitmaps, video, and sound. The drawing tools in Flash are relatively basic. The pencil and paint tools can create lines and fills of solid color, gradients, or bitmap textures. Filters are limited to blur, shadows, glow, and bevel. The library stores graphics and movie clips as "symbols" that can be reused within an animation. Flash is a fantastic tool for creating animation quickly; because it uses vectors, the files stay small and manageable. It is also great used in conjunction with After Effects, when you need to achieve a richer visual look.

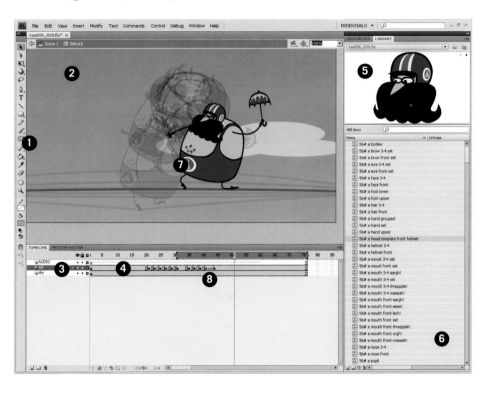

Some key tools

1 The toolbar: all the most commonly used tools are kept here.

2 The animation is laid out on the stage. Stage dimensions are fully customizable.

3 Here there are just two image layers and one audio layer, but in Flash you can have many more.

4 Key frames are added, and the timing is edited in the timeline.

5 The library stores still graphic, animation, audio, and video elements as symbols.

6 Character components are reused across a movie, allowing the production of quick efficient animation, which is easy to edit.

7 The "onion skin" feature allows you to see multiple key frames at any one time.

8 Flash has an automatic "motion tween" animation function, as well as allowing you to animate frame by frame.

◄ FRAME BY FRAME
The timeline allows you to animate traditionally frame by frame, using keyframes and inbetweens, as well as by "motion tweening" symbols.

◄ VECTOR IMAGES
Rather than working with pixels you work with the points of a vector image – which is great for creating crisp, scalable, high-resolution images.

Using Toon Boom

Toon Boom's Animate software is great for producing traditional cel animation, cut-paper style puppet animation, and any combination of the two. Art can be traditionally scanned in or created entirely digitally using the drawing tools provided. The vectorization is very efficient compared with most other animation packages. It is also a very powerful compositing tool for combining together computer animation or live action to work with the animation created in Toon Boom. The tools are very familiar to animators who have worked in other 2D packages. The workspace can be customized to make the most of the space and accommodate the needs of the individual animator.

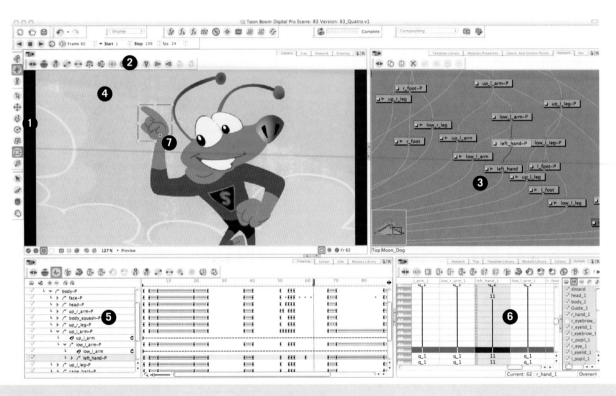

Some key tools
1 Drawing and animation tools.
2 Animation and camera move tools.
3 Network view (this is a graphical description of the art pieces and allows you to composite your images together).
4 Camera view (shows you what your final frames will look like, as well as allowing you to manipulate the character camera).
5 Timeline view (an animator can also animate directly in timeline).
6 Exposure sheets (as used in traditional animation).
7 Transform tool (in this case the hand is selected and is ready to be manipulated over time).

➤ANIMATING LIP-SYNCH
Art is created for each different mouth position. By selecting the mouth element the animator can scroll through the art and leave it exposed for a particular frame that is appropriate. This can be played back and changed interactively. Toon Boom also has an automatic lip-synch module that will decode a track and add the corresponding mouth shapes for you.

Using Maya

Maya is a 3D imaging program produced by Autodesk. It is widely used in the entertainment industry. Maya has been used to produce SFX for live-action movies, feature-length cartoons, and even computer games. It differs from 2D-based art packages because of the inclusion of the Z axis (traditional 2D programs use only the X and Y axes). This allows the user to create artwork in three dimensions. Maya's interface can be quite daunting to the novice animator.

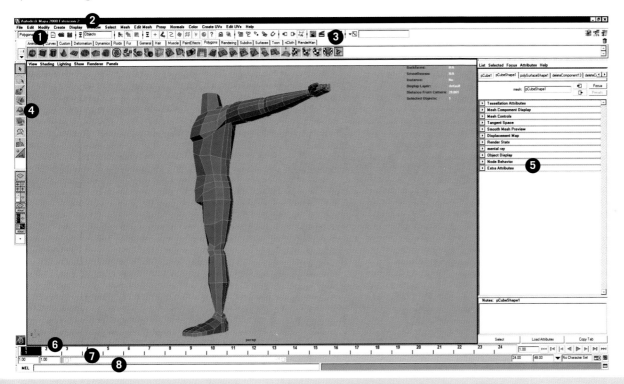

Some key tools

1 One of the most important features of the Maya interface is the hot menu.

2 When changed, this defines the main menu. Maya has six different work menus controlled by the hot menu.

3 Several of the options in these menus are also stored on the shelf.

4 The toolbar: The most commonly used tools in Maya are stored here.

5 The channel box/attribute editor/tool settings are situated here. These menus give the user access to a variety of settings pertaining to objects and nodes in Maya.

6 The time slider allows the user to scrub through the timeline to a particular point in the animation.

7 The range slider controls how much of the overall time of the scene is displayed.

8 The command line is used to input "Mel" commands. Mel is a programming script that users can input, to perform an action or series of actions within Maya.

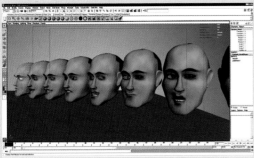

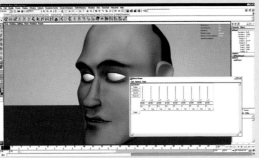

◄LIP-SYNCH GEOMETRY
(Far left) The creation of the geometry that will be used to create lip-synch animation.

(Left) The finished geometry with all the other different mouth shapes added via Blend Shape. The user is now able to set keys using the Blend Shape window.

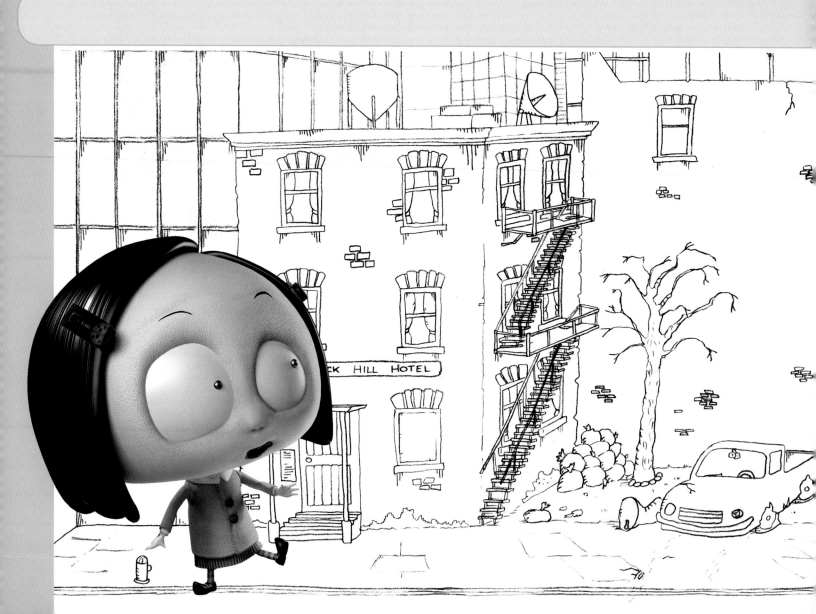

Pre-production

Every good animation starts with an idea. Developing that idea into a film is a challenging but creative task. This section looks at the first part of the animation "pipeline," which is known as pre-production. Pre-production includes scriptwriting, storyboarding, research, concept art, character and environment design, as well as organizational tasks such as budgeting and scheduling.

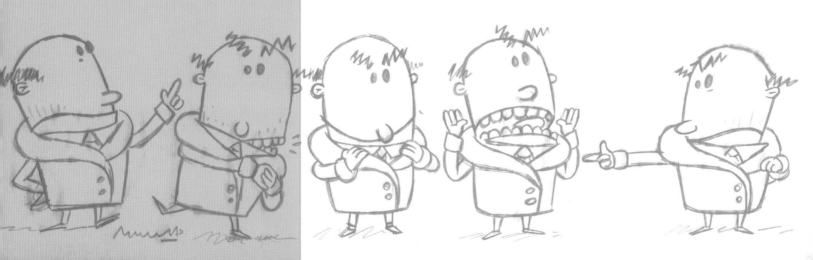

Pre-production basics

Pre-production is a crucial yet often overlooked part of the production process. This is the part where all the ideas, designs, and planning come together.

Every good animation starts as an idea. This could be something you thought of on the bus, something you discussed with friends, or an idea based on a short story or book. Essentially ideas can come from anywhere, but developing those ideas into a successful animation is a more difficult creative task. This section deals with the first part of the animation "pipeline."

In pre-production, the animation is nurtured from the initial idea until a stage where the actual animation production can commence. Pre-production is vital for two reasons. First, you need to make sure that what you are going to animate will work in terms of its storytelling structure, that the characters and environments are well designed, and that its direction and style has been clearly thought out. Second, you

need to be sure that the animation is feasible and well planned. Many potentially great projects fail because they have been badly planned or are simply unrealistic. Animation is extremely costly, and getting started without proper planning is a disaster waiting to happen. It is far easier to iron out any problems during pre-production than it is later on during the production stage.

Pre-production includes scriptwriting, storyboarding, research and concept art, and character and environment design, as well as organizational tasks such as budgeting and scheduling.

◄ IDEAS

Every animation starts with an idea, and this can come from anywhere. You should keep a sketchbook or journal to scribble down any ideas as you get them.

◄ SCRIPTWRITING

Working your ideas into a structure that will work as a film is an organic process, taking many different versions and drafts. A good script will keep the animation punchy and interesting.

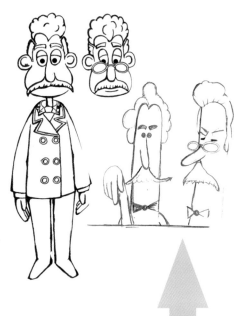

CHARACTERS

Deciding on what the animation is going to look like is the next stage, and the characters and environments are designed to fit in with the style of the script. Concept artwork is also created at this stage.

STORYBOARDING

With the design and script finalized, the next stage in the animation pipeline is to produce a storyboard that maps out the story visually and plans the pace and design of the film.

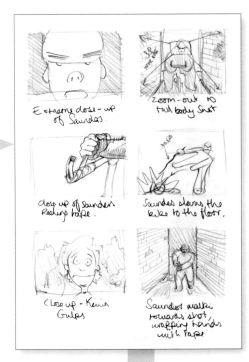

SCHEDULE

Before any animation can commence, it is essential that the animation is also planned logistically and a schedule and budget is drawn up so that the film will be completed on time and within the budget.

	Week 1	Week 2	Week 3	Week 4	Week 5	Week 6	Week 7	Week 8	Wee 9
Research									
Script									
Storyboard									
Design									
Modeling									
Animation									
Backgrounds									
Compositing									
Rendering									
Sound									
Editing									
Delivery									

Animation Schedule

Page 3

See also: Story research page 18, Visual research page 20, Scriptwriting page 22

CHAPTER 1
Pre-production

Ideas and concepts

Your animation needs an idea. Here are some techniques for finding a great concept.

One of the worst things you can do to come up with an idea is to sit down with a blank piece of paper or a blank screen on your computer. It just won't happen. This is because the brain works in very mysterious ways, and you need to tap into the part of your brain that sends out all the creative ideas.

Be ready!
Ideas will strike you at any time, day or night. How many times have you had an amazing dream, but totally forgotten it by the morning? And have you ever been discussing interesting ideas with friends and then forgotten them later on? You can prepare for these times by carrying around a small journal or notebook, and the moment an idea pops into your head, quickly write it down. Gadget-lovers will find a small digital recorder useful for recording ideas.

Brainstorming
Brainstorming works best in pairs or small groups, as it relies on quick-fire suggestions. Find a place where you will not be disturbed, and agree to these rules before you start:
• Every idea will be written down, without judgment from the other person/people.
• Any idea is acceptable, however apparently crazy or bizarre.
• Quantity, not quality, is important.
The team members then proceed to shout out ideas in quick succession to stimulate their brains into thinking quickly and creatively. Once you have finished, you should have a list of ideas that you can go through so that you can select one and develop it for your animation.

◗ PORTABLE VOICE RECORDER
A portable voice recorder is ideal for remembering ideas.

Mind Mapping
Mind Mapping uses techniques of association and imagination to map out streams of thought. The following text is an extract from Tony Buzan's website, www.buzanworld.com.

What do you need to make a Mind Map®?
Because Mind Maps are so easy to do and so natural, the ingredients for your "Mind Map Recipe" are very few:
★ Blank unlined paper
★ Colored pens and pencils
★ Your brain
★ Your imagination!
When you use Mind Maps on a daily basis, you will find that your life becomes more productive, fulfilled, and successful on every level. There are no limits to the number of thoughts, ideas, and connections that your brain can make, which means that there are no limits to the different ways you can use Mind Maps to help you.

◗ MIND MAP
An example of a Mind Map on the subject of Michael Faraday.

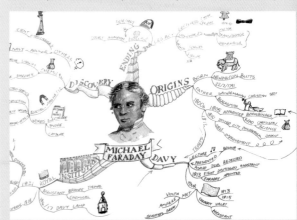

The MIND MAP trademark is used by kind permission of Tony Buzan, www.buzanworld.com.

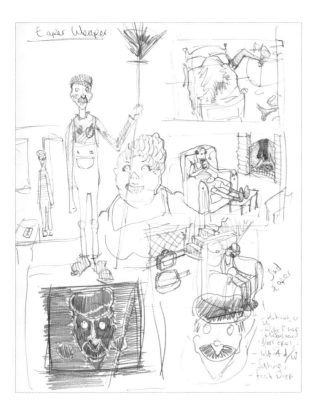

Ideas tips

- Keep a small journal on you at all times. You never know when you will want to write or sketch an idea.

- Watch as much animation as possible to keep your ideas contemporary and fresh.

- Talk to other people. Who will be the eventual audience for your idea? What sorts of things do they like?

- Give yourself a time frame to work within.

- If you feel frustrated, leave an idea for a day or two and return when your brain is rested.

◊ JOURNAL

A journal can become very personal and it is where all your ideas, concepts, doodles, and sketches start off. You should make your journal your own.

♥ THE CREATIVE PROCESS

During the creative process your studio or workspace will become a mess, so beware! But as someone wise once said, "From chaos comes creativity."

◊ POEM ANIMATION

A page from animation student Will Bowsher's sketchbook—thinking through visual ideas for an animation to illustrate a short poem.

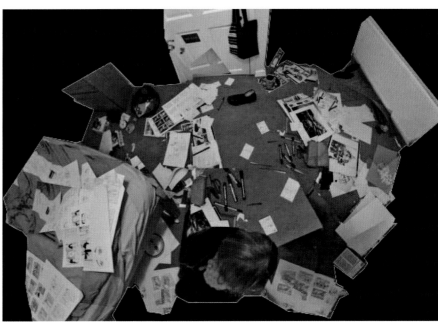

Assignment

Sketch a new small character in the center of a large piece of paper (this must be a character you have created and know nothing about). Now create a Mind Map using the tips in the box, left. The result should be a comprehensive map with creative ideas on how that character could be developed.

See also: Visual research page 20, Scriptwriting page 22, Character design page 40

Story research

Whatever style or technique of animation you decide to use, every animated film has one thing in common—a good story.

As a race, humans have been telling stories for thousands of years. It has been suggested by scholars that there is only a very limited number of possible stories. In his book *The Seven Basic Plots—Why We Tell Stories* (Continuum, 2004), Christopher Booker theorizes that whatever the story, it can always be stripped down to one of these seven basic structures:

1. Overcoming the monster
2. Rags to riches
3. The quest
4. Voyage and return
5. Comedy
6. Tragedy
7. Rebirth

Story tips

- Let your imagination flow—in animation, anything can happen, and with the whole range of potential techniques at your disposal, the only limit is your imagination.

- Produce a very detailed character profile of every character in your story.

- Do a situation test. Imagine your characters in any situation. How would they react?

- A story must have a beginning, a middle, and an end. But not necessarily in that order.

- Use observation— to make your characters believable, research how particular people act and react.

- Use conflict in your storytelling. This is a useful device for drama and comedy as well as good character development.

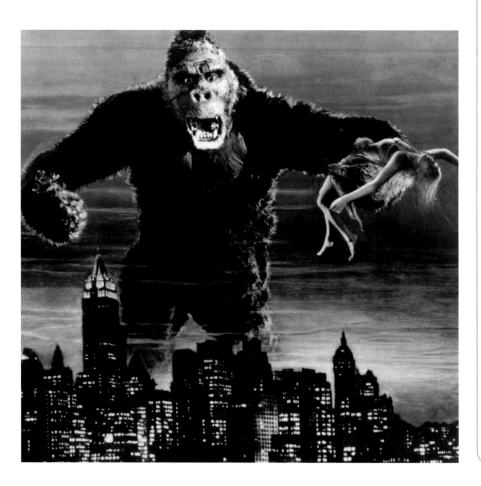

◄ OVERCOMING THE MONSTER

"Overcoming the monster" is a theme used in storytelling time and time again and is one of the basic plots used in many animated films, such as King Kong.

Conflict theory

A literary theory known as "conflict theory" makes the case for seven different basic story plots:

1. (Wo)man vs. nature
2. (Wo)man vs. (wo)man
3. (Wo)man vs. the environment
4. (Wo)man vs. machines/technology
5. (Wo)man vs. the supernatural
6. (Wo)man vs. self
7. (Wo)man vs. god/religion

◦ LOOK AT COMPUTER GAMES

Really good animation engages the audience in exactly the same way as an absorbing book or a computer game. When casting around for a story immerse yourself in many different types of media, and make your diet as varied as possible, including animated computer games.

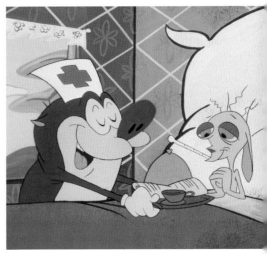

◦ FULLY DEVELOPED CHARACTERS

One of the crucial aspects of good storytelling is to have well-researched and fully developed characters. A good test is to put a character in a situation and imagine how the character would act and react. Homer Simpson is a good example, because you can imagine him reacting to any situation.

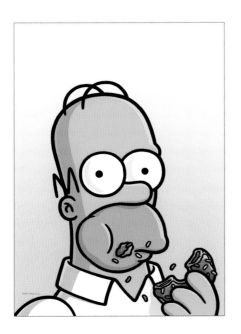

For a story to work, the audience needs to feel engaged, and this can work on a number of different levels. For example, in a computer game you are engaged in the story as one of the characters; in a commercial advertisement clever writing and aesthetics expose you to the appeal of a certain product; in a feature film you devote 80 minutes of your life to be taken on a journey and engaged in another world. If the audience doesn't feel engaged, they will feel cheated.

In its simplest terms, a story must have a beginning, a middle, and an end. At its most complex, a story can have complicated plots and narratives, sub-plots, metaphorical meanings, symbolic references, and narrative twists to keep an audience on their toes.

Good character research is also essential. The relationship and conflict between characters is often what drives the story. You want your audience to not only be engaged in the story but to relate to and care for the characters. Why should the audience be bothered about your heroine's terrible demise if they don't really care about her? You need to make sure your characters are believable and real. You should really get to know your characters, down to every small detail of their personality, and understand how they would react in any situation.

◦ DOUBLE-ACTS

Conflict is what drives most stories and characters. The comedy double-act (such as Ren and Stimpy, above) is a device used by writers to encourage audiences to believe in the characters and therefore care about them, essentially because they understand that deep down the characters, despite almost constant conflict, really care for each other.

📁 Assignment

Create a character profile of a fictitious character. The profile should contain as much information as possible, as if your character were real. Where were they born? Who were their parents, what food do they like, what sports do they enjoy, who are their friends, where do they live? And so on. Always do this for a character before you attempt to write a script or animate the character.

See also: Ideas and concepts page 16, Concept design page 34

CHAPTER 1
Pre-production

Visual research

Once you have an idea, you need to flesh the concepts out into the basis of an animation.

From a visual perspective, how do you envisage your idea looking? You may want to base it in 17th-century France, modern-day Cuba, or the future. What will things look like, and how will it affect your design? Details such as costumes, architecture, landscape, transportation, and social customs are all-important and vary enormously. If you do want to set your idea in a specific time period you will need to do some serious research and make sure you get all your facts right.

Unlike live-action filmmakers who are often able to travel to particular locations to shoot their films, animators are left in their studios imagining what their locations are like. It is therefore really important to make a substantial research journal and mood board.

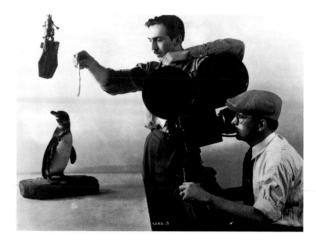

Visual research tips

• Keep an open mind and watch as many films and TV shows and read as many books about the subject as possible.

• Don't use only the Internet for research.

• Keep a camera on you at all times and take photographs.

• Always have a target audience in mind.

• People are a great source of research. There is nothing better than a firsthand experience.

• Always back up your facts with a second source.

❢ FIELD TRIP
A team of Pixar artists made a trip to Paris before the production of Ratatouille *started to soak up the atmosphere, sketch and photograph the buildings, taste the food, and observe the culture.*

▲ REAL-LIFE REFERENCE
Walt Disney would always encourage his artists to research the behavior of animals that appeared in his films. Here Disney feeds a penguin to provide reference footage for the artists to animate the 1934 Silly Symphony Peculiar Penguins.

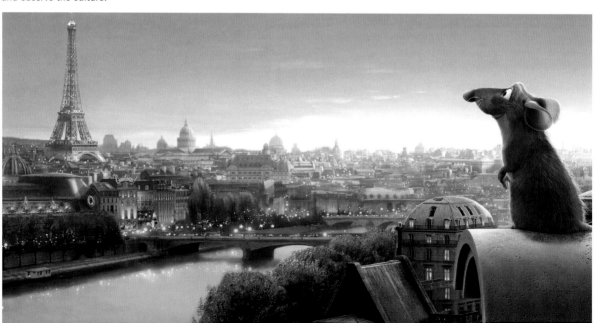

Character research

Before you start animating your characters you will want to research how your characters should "act." For example, a 20-year-old male character based in New York City in the 1970s will have a completely different cultural identity from a 20-year-old male based in Italy in the 15th century, and the animation style should reflect this.

Audience research

If you intend to make your animation appeal to a specific audience, make sure you understand that audience, and that the film you make is appropriate. Talk to people who would potentially be interested in your idea and find out what they would like to see. Show them initial sketches and get feedback. This will eventually contribute to a stronger animation.

Production research

How are you going to make your film? Is the technique or style you are hoping to use going to be feasible? Seek advice and speak to people who are familiar with the technique you are attempting.

Visual referencing

A mood board is a source of visual referencing that can be used to determine the mood of the film. Indicative colors, designs, inspirations, doodles, and photographs all contribute to the overall feeling you may require.

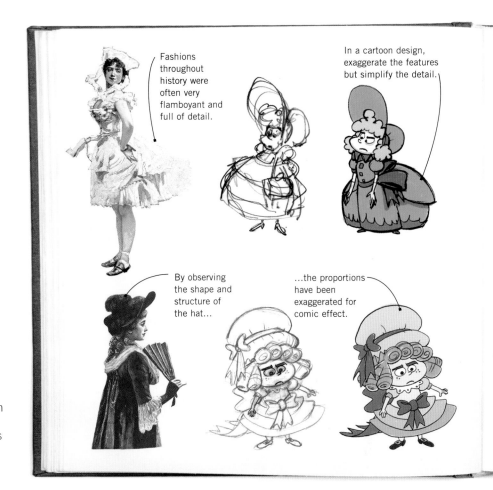

Fashions throughout history were often very flamboyant and full of detail.

In a cartoon design, exaggerate the features but simplify the detail.

By observing the shape and structure of the hat...

...the proportions have been exaggerated for comic effect.

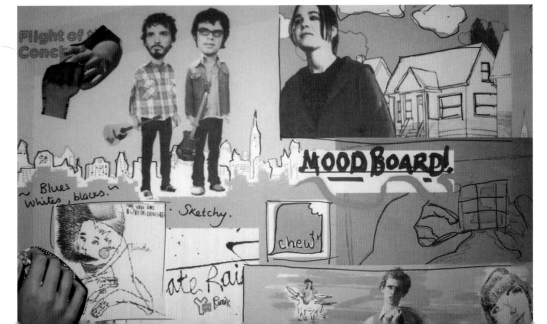

COSTUMES AND PROPS

Always base your design work on the correct reference material. Costumes and fashions, for example, vary enormously throughout history and different cultures, and your design needs to replicate this. There are hundreds of good reference books available, or take a trip to a museum to study the costumes close up.

MOOD BOARDS

Make a collection of images that inspire you, cut out from magazines or printed from the Internet, and stick them to a large piece of cardboard to start to get a visual feel for what you are after. Think about colors, graphic style, and design. Postcards are also a great source of visual inspiration.

See also: Story research page 18, The storyboard page 24, Voice recording page 52

Scriptwriting

Pulling all the ideas and concepts into a focused blueprint for the animation is all part of scriptwriting.

As any writer will tell you, scriptwriting is a process that goes through several stages before a script is considered polished enough to be complete.

The treatment
The first stage is to produce a "treatment," which is a summary of the action, themes, and style of the story and can vary in length from a paragraph to a few pages. It is important to be able to summarize your story at this point in case you need to pitch the idea.

The outline
The second stage is called the outline, where you need to plot out the basic premise, plot points, and key events in the animation. This can be in the form of a series of bullet points or a hand-drawn list of events that forms the basic structure of the film. At this point there are no specific stage directions or dialog and it is purely the structure that you should be concerned about. Outlines will obviously vary depending on the

type of project but, whether it is a short film or a feature, you will still need to write an outline.

Drafts
The early drafts of a script should be written quickly, without formatting, to allow as creative as possible a stream of words. Mistakes can easily be corrected at a later point, but at this stage you should concentrate on ideas. A writer will often go through several drafts tweaking dialog, homing in on certain characters, increasing tension, adding gags, or whatever it needs to make the script as punchy, interesting, and entertaining as possible. The final draft is the blueprint for your project, and should contain polished dialog, stage directions, and a solid structure in the narrative.

Formatting
The final task before your script is complete is to format it into a layout that is acceptable as a standardized screenplay.

Scriptwriting software

To make the formatting and layout of your scriptwriting quicker and simpler, there are a few software packages available that format your script into industry-standard layouts automatically (see example, right). These programs will also keep lists of all your characters and locations and track all your changes, making rewriting and tweaks easier.

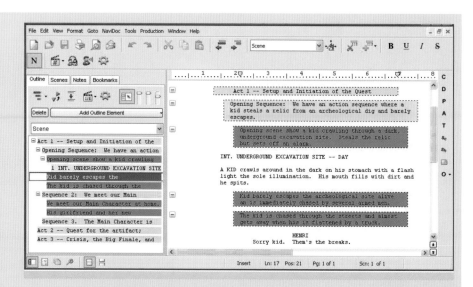

➤ **SAMPLE SCRIPTS**
The example from Johnny Casanova the Unstoppable Sex Machine *by writer Jamie Rix is a good example of how a well-formatted script should read.*

The name of the character talking is always in capital letters and centered. The dialog should be in regular type and centered below.

You may wish to add a stage directive to indicate how the line should be delivered.

You can indicate camera directions such as a "cut" or "wide shot." See pages 28–31 for more about types of shot. Your script should contain detailed stage directions for the action.

A "single" indicates that you would like a single shot of Johnny, with no one else in the shot.

A well-formatted script is easy to read and has space for other crew members to add their own notes.

"POV" refers to point of view: in this case, Johnny's.

"SFX" refers to sound effects.

A "whizz pan" is a very quick camera move, often accompanied by a whooshing sound effect.

The scene heading in bold tells us where and when the action is taking place. ("INT" is short for interior.)

The stage directions for animation scripts are often more concise than for live-action scripts. They are usually written in the present tense.

 JOHNNY
 But I'm here to pick up Sherene.

 BALLET TEACHER
 (smirking)
 Then why are you dressed like that, Bubula?

CUT TO:
Wide shot. We see that JC is dressed in a pink tutu and frilly tights.
Alison is horrified. She starts to weep.

 ALISON
 How could you do this to me, Johnny, when you know how much I love
 you, I thought you were a man!

CUT TO:
Single of JC despairing.

 JOHNNY
 But Alison!

Suddenly, JC freezes with horror. He pushes the tutu down over his
bits to preserve his modesty.

CUT TO:
JC's POV.
At the end of the drive there is a coachload of girls including the
Purple Goddess and everyone from school. They are hanging out of the
coach and standing on the roof howling with laughter and pointing at
JC's tutu.
SFX: Girls shrieking with derision.

WHIZZ PAN TO:
SCENE 13
INT: JOHNNY'S BEDROOM. EARLY MORNING.

Close Up. JC sits up into camera. He is in bed. He is sweating. He
has woken from a nightmare. He tentatively puts his hands to his head
fearing lest his hair really has been shaved and sighs. His hair is
still there, slightly shorter but fine. He smiles. The kiss curl
shoots up.

CUT TO:
SCENE 14
INT: LANDING OUTSIDE JOHNNY'S BEDROOM. EARLY MORNING.

Sherene is lying on the floor next to Pongo. Next to her is the Flea
Circus, the circular tray with Rice Krispies...
CONT..

See also: Film language page 28, Types of shot page 106, Editing animation: theory, page 128

The storyboard

Now that you have captured the plot and structure in words, it is time to visualize the story.

A storyboard is a visual plan of the whole animation, which charts the action in a sequence of drawings, presenting the story and the style of the film. To be a storyboard artist you need be part director, part designer, and part writer. As with other tasks to be done along the animation pipeline, most storyboard artists work through a similar process.

The thumbnail storyboard
Called thumbnail sketches because the drawings are so small, the action is visualized very roughly, often actually on the script itself, to give a sense of the flow. Although rough, it allows the director of the film to make sure their vision of the film is going in the right direction.

The rough storyboard
With a fairly good idea of how the film will flow, the next stage is to produce a rough storyboard. The drawings for this can vary in size and quality and, because the artist will want to experiment with changing the order of sequences, can be drawn on postcards or sticky notes.

The cleanup
Once the artist is happy with the way the storyboard is working they will clean up their images and refine them to fit a particular format, adding notes for stage directions, camera moves, or any particular effects. There are two types of cleaned-up storyboards. One is known as a "presentation storyboard," which is often fully colored and drawn to a very high standard, and will be used to present the idea, often to a client in an advertising agency. The other type, known as the "production storyboard," will be drawn more quickly and not usually in color. This is designed for the production crew, and will not normally leave the studio.

The animatic
To make sure the timing of the film is working well, an "animatic" (sometimes referred to as a storyreel) will need to be made. This will be the first time the visuals will be seen running to time and is an opportunity to check that a particular shot has been given enough time for it to read. The animatic will often include a "scratch track," which is a very rough soundtrack using the voices of members of the team and music that represents the final sound.

► DIGITAL STORYBOARDS
Many storyboard artists now work digitally, and these animatic frames from The Adrenalinis *were drawn directly into Flash using a Wacom graphics tablet. In fact with digital 2D, it is now possible to have the whole production pipeline almost entirely paperless.*

Case study: Using a script to plan a storyboard

Once the script has been finalized, the next stage of the process is to think how the words on the page are going to work visually. This page from the script for a short animated film by Nick Mackie illustrates how the animator has started to think about certain shots with small thumbnail doodles on the script.

You may have a vision for a shot that includes a particular location, or perhaps a specific movement for the animation, and even if they don't end up in the film, scribbling ideas on the page will help shape the film.

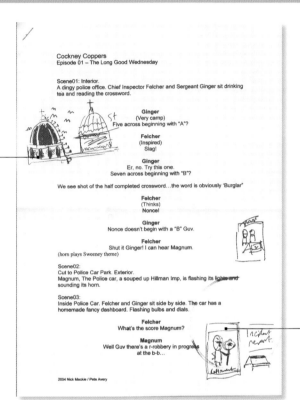

To ensure that their final vision of the animation materializes, many animation directors will brief the storyboard artist by going through the script and making little notes and sketches on the script.

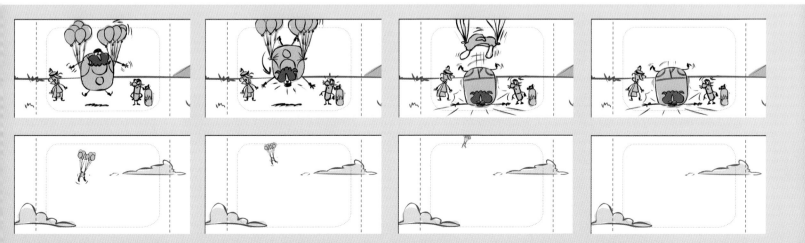

In this rough storyboard, the sequences of animation start the buildup and will eventually dictate the flow of the film. Note how the shots use a variety of camera angles to keep the mix interesting.

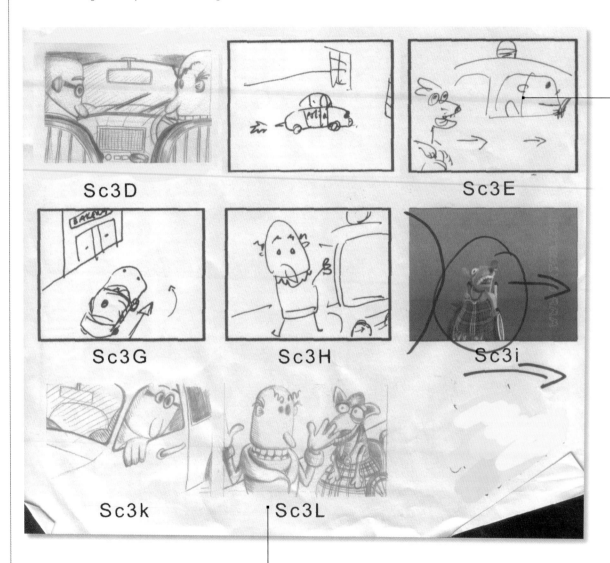

Sc3D

Sc3E

Sc3G

Sc3H

Sc3i

Sc3k

Sc3L

At this stage of storyboarding, don't worry how loose or sketchy your drawings are. Storyboarding is not about good drawing, it is about the creative planning of shots and sequences.

How you number your shots and sequences is up to you, as long as it is logical. These shots are all from Scene 3 and are labeled with the letters D–L.

Once the rough storyboard has been approved, the drawings can then be cleaned up and, with approval of the director, it may be possible to add a few visual gags.

The final storyboard is now starting to take shape. Arrows indicate camera moves, there is good use of close-ups to help tell the story visually, and a sense of character is starting to emerge.

For a "presentation" storyboard you may add color and draw in more detail. However, these are normally used only for pitching sessions or commercials; most production storyboards remain uncolored.

See also: The storyboard page 24, Types of shot page 106, Lighting page 112

Film language

When you create a storyboard, you are venturing into the world of cinematography, where choices about shot composition, design, lighting, and camera angle have to be decided.

The types of shots, and when and where they are appropriate, are discussed later on (see page 106), but you have to effectively imagine you are shooting the sequence through a camera lens, and that the camera can move, tilt, be focused on a close-up or on a wide shot, be looking down on a subject, or be looking up.

There are many rules of film language and aesthetics that apply equally to film editing and storyboarding, which you need to understand to make your storyboard work properly. There are suggested books in the Resources section that give excellent guidance on this.

Crossing the line
When planning a sequence imagine a line drawn through the center of the action. You can compose the shot from any angle, but as soon as that line is crossed, you will disorient your audience. The easiest way to remember this is to imagine you are choosing different seats in the audience for a play to get the best view, and that backstage is not an option. Never storyboard a scene from every conceivable angle just because you can—limit your angles to three or four camera positions.

Cutting
Check that one shot cuts to another. A general guide for this is to keep shots varied and never cut from one shot to another if they are at all similar. For example, a mid-shot with two people to another mid-shot of another two people generally won't work.

Shot hookups
The action should always hook up from shot to shot. Keep all the action flowing in the same direction, and watch the continuity too.

Composition
Although the whole point of a storyboard is to plan the action, take care when composing the shot, as if you

were a photographer looking for the most interesting angle. Avoid parallel floor lines and symmetry, and if you are showing a two shot (two characters in the frame), then one character should be higher to add interest.

ORIGINAL VERSION

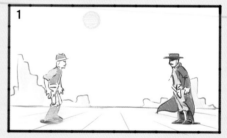

Wide establishing shot. Shows us location and characters in relation to each other.

IMPROVED VERSION

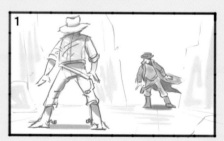

Wide establishing shot. Shows us location and characters in relation to each other.

Assignment

Choose a short poem or a verse of song lyrics and visualize a sequence of images into a storyboard appropriate for that style of poetry or song. Once you have finished, think how you would redraw it in another genre, for example how different it would look if you were to draw it in an anime or a comedy style.

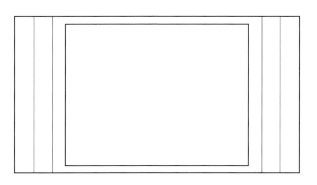

▼ EXAMPLE STORYBOARDS

Compare these two examples, In the second, care has been taken to make sure one shot flows well into the next, that there is a mixture of close-ups and long shots, and that the camera angles are varied.

▲ STORYBOARD FORMATS

The two most common formats you need to storyboard in are wide-screen (16:9, which is the main black area) and standard (4:3, within the red area), which relate to the aspect ratios of most television screens. The smallest box indicates a "graphics safe" area, within which you should keep any text. To avoid any important images being cut off or missed, the main action should take place within the "action safe" areas indicated by the smallest box for 4:3 and by the green lines for 16:9.

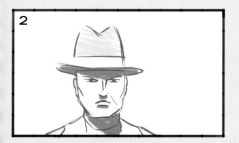

Cut to close-up of the Sheriff.

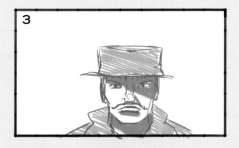

Cut to close-up of the Bandit. Very similar to previous shot.

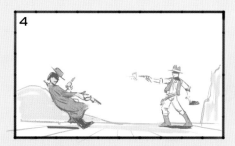

Cut to wide shot as Sheriff shoots the Bandit. Having established the geography before, here we have crossed the line. The Sheriff and the Bandit have swapped position in this shot.

Cut to the Sheriff. Using a low angle makes the Sheriff seem larger and more threatening. Having the sun behind him and casting him in shadow also makes his expression harder to see.

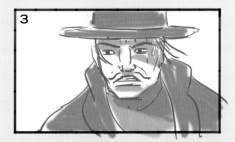

Cut to close-up of the Bandit. The Bandit favors the right-hand side of the shot. We have cut in closer to see how the Sheriff makes the Bandit feel. We can see his worried expression and sweat on his brow.

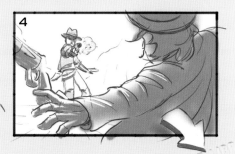

Cut wide as the Sheriff draws first, seen almost from the Bandit's point of view. The Sheriff draws quickly, and as the Bandit falls out of shot we're left with just the Sheriff standing victorious.

"OOglies" animatic

Here is a series of frames from an animatic by Joe Wood for the UK children's animated sketch show *OOglies*. This is a good example of film language in a sequence that uses a variety of shots to give the animation flow, pace, and excitement.

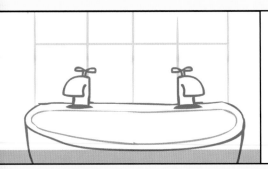

SHOT 1 A

(a shot may need more than one frame)

The sequence opens with an MS establisher of a bathroom sink.

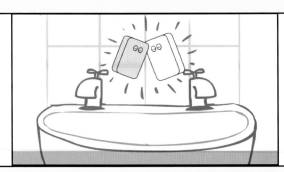

SHOT 1 B

The two characters (bars of soap) enter shot as if they are on skateboards, and high-five each other.

SHOT 3

Cut to an MS of the soaps spinning around the toilet seat a couple of times.

SHOT 4

Cut to LS which is looking down on the characters. This not only gives a sense of scale, but also gives a different style of shot to keep the shots varied. This type of shot is called a "down shot."

SHOT 7

Cut to MS as the soaps slide down a banister. Note how the compositions of each shot vary to keep the visual interest.

large crash off screen

SHOT 8

Cut to MS on mantelpiece. One soap lands safely, the other one lands OOS, SFX. To exaggerate a crash, the storyboard artist will sometimes use "camera shake."

CU = close-up; LS = long shot; MS = medium shot; OOS = out of shot; SFX = sound effects.
For more information, see Types of shot, page 106.

SHOT 1 C

After spinning around the sink a couple of times the soaps exit to the right.

SHOT 2

Cut to an interesting angle looking along a windowsill. The soaps slide toward camera. It is always good to use depth, and having the action come up toward or away from the camera can add impact.

SHOT 5

Cut to MS with the characters coming right up to camera (in fact they jump over the camera), giving great impact and pace.

SHOT 6

Cut to MS as the soaps fly through the air.

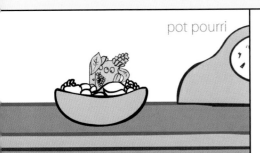

pot pourri

SHOT 9

Cut to MS. Reveal that the other soap has landed in bowl of potpourri. This works as an MS but would work just as well as a CU, allowing the viewer to see more of the character's expression and reaction.

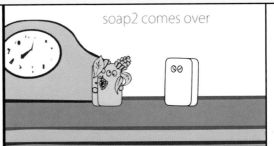

soap2 comes over

SHOT 10

Cut to MS of final payoff. White soap sniffs other soap and reacts. Both characters laugh.

End.

See also: Ideas and concepts page 16, Scriptwriting page 22, Concept design page 34

Mini bible

If you are hoping to get funding for or interest in your idea, you will need an exciting presentation of the project: the "mini bible."

The purpose of the mini bible is to sell your idea. The mini bible is not a production bible, which will come later, but should be an effective sales tool to get potential investors and partners excited about your project. Think of it as being like a car brochure.

Every project varies, but a mini bible should never be an intimidating document. It should be clear, concise, and punchy. Use plenty of color images throughout and avoid huge clumps of text.

Front cover
Always make the front cover of your mini bible as eye-catching as possible, and encapsulate the whole style and feel of the project. The title of the project, possibly with a logo, should be clearly shown. Remember that if you are sending this to an investor who receives hundreds of proposals, you want yours to stand out.

Inside cover
If you can grab the attention with a great front cover, then you have cleared the first hurdle. Next you need to spell out exactly what your project is with a catchy slogan, a definition (an animated comedy series, for example), a description of how long the project is, and if it's a series, how many episodes there are. You may also want to mention the key talent involved, particularly if any of the team has a good track record.

The concept
This information should be limited to a page and should explain the whole idea, including the characters, any conflicts, themes, or relationships. You should also include a description of the design style, the tone of comedy or action, and crucially, the target audience.

Principal character descriptions and designs
Describe the main characters in the project. Don't just give physical descriptions but try to describe their personality traits, their characteristics, and, very important, their relationships with other characters. This is what really drives a good idea. At this stage, conceptual designs for characters are adequate, so don't worry about turnarounds or expression sheets.

Backstory and setting
Is there anything the audience needs to know in order to understand the idea? If so, that needs to be addressed in the mini bible, as does a description of the location, the time period, and the tone and pace of the animation.

Episode premises
If your idea is for a series, then include information about at least six episode concepts, each one of which should have a beginning, middle, and end.

▼ **INCLUDING 3D**
Your mini bible should contain images that are indicative of the project. If you are creating the project in 3D then you should endeavor to include mocked-up 3D images. The mini bible for Dr. Diablo *by Jamie Rix included several small conceptual sketches of the main character, Mary, in several expressive poses, and one 3D character setup.*

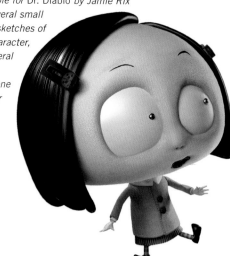

Mini bible tips

- Come up with the best slogan you can. The pitching slogan for *Alien* was, famously, "*Jaws* in space."

- Don't be afraid to make comparisons with other films or shows in your mini bible if it helps describe your concept.

- Write as if you are talking.

- Check spelling, grammar, and punctuation.

- Make sure you have considered your target audience.

- If possible, get a professional writer to give your bible a final polish.

← MINI BIBLE EXAMPLE

The purpose of a mini bible is to get potential investors, key talent, and of course broadcasters excited about your idea. It should be designed as a sales tool and contain as much information about your concept as possible, but kept to a clear, concise, and punchy format.

A page from the *Gilmerton Heights* mini bible, clearly showing the style of the design, with samples of the characters and background designs.

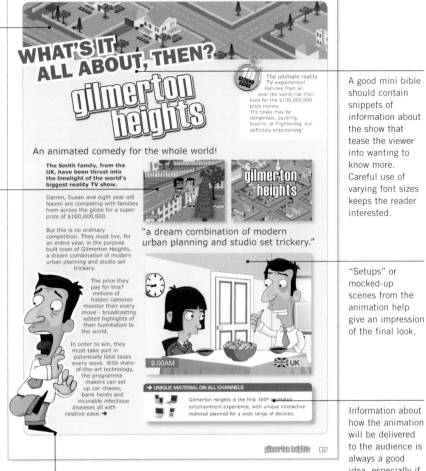

A good mini bible should contain snippets of information about the show that tease the viewer into wanting to know more. Careful use of varying font sizes keeps the reader interested.

"Setups" or mocked-up scenes from the animation help give an impression of the final look.

Information about how the animation will be delivered to the audience is always a good idea, especially if it involves new technology.

Character concepts in exciting poses peppered throughout the mini bible are both visually interesting and tell plenty about the characters.

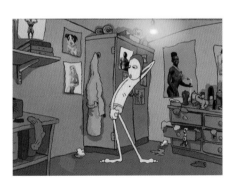

◊ SETUP

A "setup" is a design for the animation which gives an indication of the final look of the project by including a few characters and the background. This suggests to any potential investors or partners an idea of what the animation will actually look like. The details in the background from this setup from Johnny Casanova the Unstoppable Sex Machine *tell us as much about the character of Johnny as any words could.*

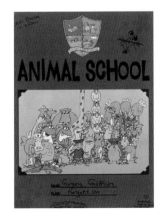

→ MINI BIBLE COVER

Be imaginative with the cover of your mini bible, and try to think of something that reflects the theme of the project. For the mini bible of Animal School, *the cover was designed to look like a tatty school journal with a class photograph stuck to the front.*

See also: Environment design page 36, Character design page 40

CHAPTER 1
Pre-production

Concept design

Digital animation can be designed to work in any visual style, and with a multitude of techniques at your disposal—from realistic to abstract, two-dimensional to three-dimensional—you really can create a unique world.

The following pages discuss the actual design and style of your film and the important process of getting all your research and planning to a point at which you can start the production.

Animation differs from other forms of filmmaking in that you have at your disposal complete control over how the film will look, but it is surprising how many novice animators overlook this.

Concept art

Visual research is essential, and this is where all your photos, sketchbooks, and journals come into their own. Working from your mood board and research material you can start to produce some concept art.

Concept art can be in any medium. Whatever medium suits you is fine—pastels, pencils, felt-tip pens, montage or modeling clay, or of course digital—

Case study: Setting the style

When Nick Mackie started designing the style for this film, he wanted to have a feel for the 1950s UPA cartoons, but rather than animate in two dimensions he decided to create the design by having three-dimensional characters in a stylized two-dimensional environment.

There is also a very strong influence from 1970s cop shows, and to make the whole film look a bit grubby, Nick added a layer of stained brown paper over the top of the animation.

▼ CHARACTER CONCEPTS
Working from some early sketches, the character concepts were designed. Nick wanted his characters to have "flip-top heads" for when they spoke, and this rough model sheet shows early attempts to get the most expression out of a simple but effective design.

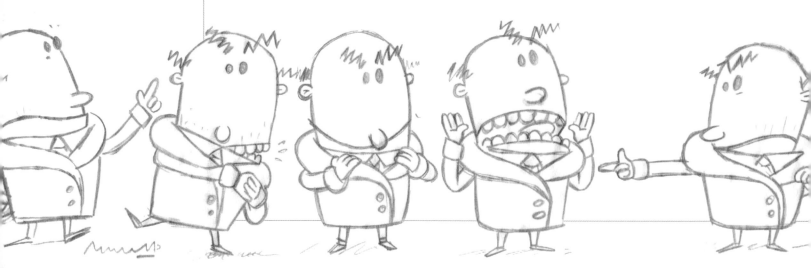

▲ COLOR AND DESIGN STYLE

In this concept illustration, designer Rafi Nizam clearly indicates the proposed style, both in terms of color and design style. This example was drawn with pencil on paper and then digitally colored.

anything goes. The whole purpose of concept art is to establish a general feeling for the design, through the color palette and style. Concept art should be free and loose, unrestricted by any parameters, and characters should be suggested rather than vigilantly drawn. These early stages of concept art are very organic and the design can start to take on a life of its own.

The process of visually conceptualizing your idea should be a liberating and highly creative process and if possible you should try not to copy an existing style or design. Your mood board (see page 21) will have all the influential design ingredients contained within it, and from these you can pick out the elements you want to use.

The main objective of this organic process is to produce a "setup" or finished piece of artwork which is indicative of the final look of the film. The "setup" would normally be in a location typical for the film and should include at least one of the characters.

▲ CHARACTER DESIGN

Influenced by 1970s cop shows, the characters wore sheepskin coats and had an unkempt appearance emphasized by textures and an overlay of stained brown paper. Nick wanted the characters to resemble traditional stop-motion characters but without the clay-style mouth.

▲ ENVIRONMENT DESIGN

Despite looking distinctly two-dimensional, these environment designs were actually modeled in three dimensions and rendered out to look two-dimensional. The palette was kept very simple with block colors and grubby textures.

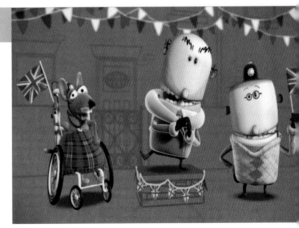

▲ THE SETUP

This final setup, with the characters placed on the background, demonstrates how the characters blend into their environment. As the backgrounds are kept simple, the three-dimensional texture detail in the characters brings them out to the foreground. The muted and grubby color palette gives an overall sense of design consistency. Note how the characters have also been emphasized by the slight blur on the background.

See also: Concept design page 34, Character design page 40

Environment design

The art of designing an environment for animation is really about designing the whole film. An environment should be striking and yet uncluttered to allow the characters to work within it.

To design a successful environment, you should first take a look at set design for stage and screen, as this is in effect what you are doing.

You are creating an environment for your characters to act and perform in and, while it has the important job of telling the audience when and where the characters are, it must not dominate the shot. Some very successful environment designs are nothing more than a few lines to suggest location, perhaps with a splatter of color, whereas others are fully rendered, photorealistic three-dimensional environments. What you decide to do is up to your own preferences but will also depend on what is appropriate for the animation you want to produce.

Achieving balance

The characters must sit comfortably within the environment. A good environment design will look off-balance and perhaps a little empty until a character is placed within it. If the environment is too busy, or contains an obscure angle, it may have a detrimental effect on the film; or if the audience feels hemmed in by too-complicated and busy environments, it will make them feel uncomfortable.

Worm's-eye views, overhead shots, and very low camera angles are always interesting, but don't use these for every shot in your film. Use them sparingly to add a little eye candy every now and again, and for a particular reason.

Once you have an environment design that you think works, ensure that you test it by producing a "setup," placing some characters within the design to make sure that the characters and background work harmoniously (see page 33).

Environment tips

- Always keep the composition as interesting as possible, manipulating the audience's eyes toward specific areas of attention.

- Don't use heavy, bold, or primary colors. That will just make your animation look too busy.

- Allow space for the action to take place. A good environment design should be slightly bare.

- Keep it simple.

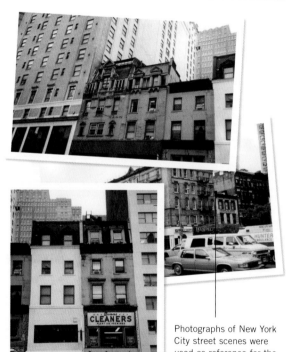

Photographs of New York City street scenes were used as reference for the design opposite.

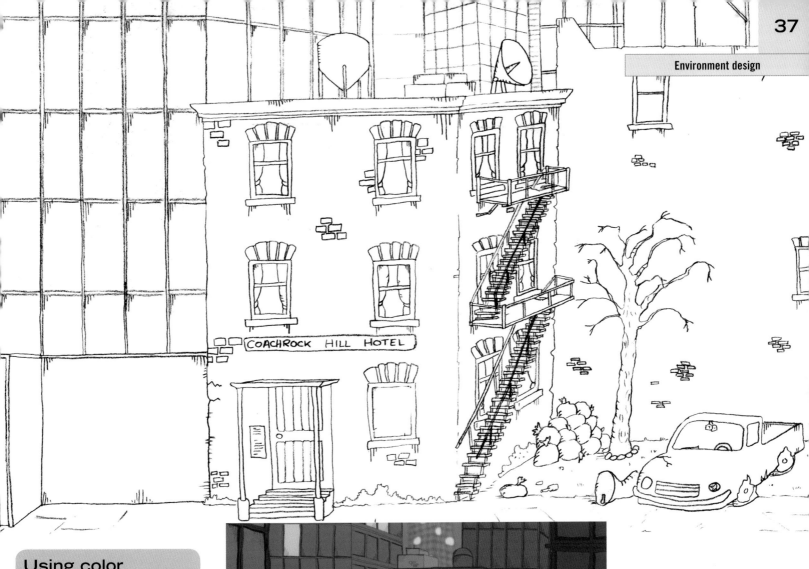

Using color

• Bold and heavy colors and contrasts are best avoided in environment designs, because these will distract the audience's eyes from the important action of the film. But you can use color to emphasize the emotion and atmosphere of your film, and it is always advisable to design your script in color.

⬥ **ENVIRONMENT RESEARCH**
If you are designing an environment based on an existing place, it is important that you refer to photographs and sketchbooks to ensure that particular architectural features are correct in your design. The concept designs shown here use a typical New York style for the overall look.

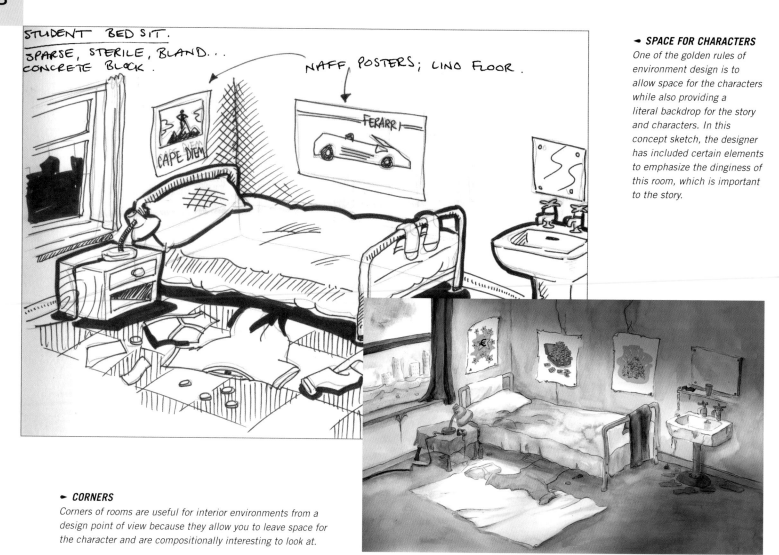

STUDENT BED SIT.

SPARSE, STERILE, BLAND...
CONCRETE BLOCK.

NAFF POSTERS; LINO FLOOR.

CAPE DIEM

FERARRI

➤ SPACE FOR CHARACTERS

One of the golden rules of environment design is to allow space for the characters while also providing a literal backdrop for the story and characters. In this concept sketch, the designer has included certain elements to emphasize the dinginess of this room, which is important to the story.

➤ CORNERS

Corners of rooms are useful for interior environments from a design point of view because they allow you to leave space for the character and are compositionally interesting to look at.

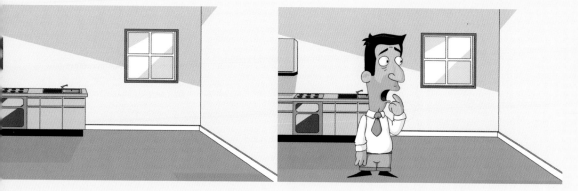

➤ KEEP ENVIRONMENTS BARE

Environment designs can be relatively devoid of detail, because it is the characters that make up the scene. Simple vector designs are very easy to do and are very effective as backgrounds. The kitchen environment from Gilmerton Heights does look bare without any characters, but as soon as characters are placed within the environment the whole composition and dynamics of the scene change.

◊ LIGHT

In this three-dimensional rendering (of the same environment as the one on the right) by animation student Simon Acty, the atmosphere is matched with the design through the use of a strong light shining in through the door.

♦ COLOR

Color is an important device for suggesting mood and atmosphere in an environment design. In this concept drawing the deep browns and reds evoke a dark but warm environment. Our eyes are drawn toward the lighter parts of the design.

➡ COMPOSITION

This environment design by Kathy Nicholls draws the eye into the empty space toward the bottom of the picture. It was originally designed as a pan, and the camera would have moved from top to bottom, leaving the audience looking at the space in anticipation of the characters starting to perform.

📁 Assignment

Design and stylize an interior environment. Using light, color, and various artifacts, and the general design of the interior, try to indicate what time of day it is and also where the room is. For example, a room in a New York apartment at sunrise will have a very different feel from a farmhouse in rural France at sunset.

See also: Concept design page 34, Environment design page 36

Character design

Whether you want to make a stylized or naturalistic animation, the design of the characters must be established early on in the process. They are the main vehicle through which the story will be told, and they must be designed with this in mind.

Character designers must fully immerse themselves in the script and attempt to understand what makes the characters in the story tick, and then work those traits into a design appropriate to the story and genre.

Digital animation is a wonderfully flexible medium in terms of how far the design can be pushed away from lifelike naturalism; in fact, paradoxically, the closer the design is to reality, the less appeal it has. It is for this reason that some of the most successful character designs in animation history look nothing like real people or animals, and yet they ooze so much personality and appeal.

◗ TYPES OF MEDIUM
In addition to style, you should also experiment with different techniques to get an interesting and unique design.

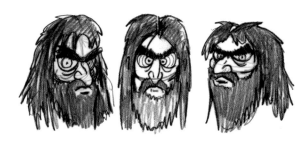

▶ LIFE DRAWING
A good character designer needs to keep life drawing in order to develop skills in anatomy and drawing. This is an example by character designer and animator Rafi Nizam.

◗ SIMPLE DESIGN
Foo Foo, one of the characters designed by the British studio Halas and Batchelor, demonstrates pure simplicity in design—constructed with little more than a circle and a square, and yet with great personality and character.

◗ PERSONALITY
When designing characters you should always strive to capture their personality, as you are in effect casting the actors for a film. Each character should be different in personality, but similar in style so they can sit together comfortably on the screen.

Character design tips

- Attend regular life drawing classes to develop your understanding of anatomy and drawing skills.

- Keep your character designs simple. Complex character designs are often difficult and time consuming to model and animate.

- Make sure the eyes of your character are as expressive and as appealing as possible. This is what the audience will look at first.

- Avoid absolute realism in your design. The paradox of "uncanny valley"* is a problem faced by many three-dimensional characters and means that the more real your character looks, the more zombielike and unappealing it will actually be.

*The uncanny valley is a theory put forward by Japanese roboticist Dr. Masahiro Mori, who observed that there is a point at which a person observing a humanoid robot sees something that is almost human, but not quite human enough and it actually appears eerie and weird.

Design considerations

Good design for animation depends on simplicity. A well-proportioned combination of shapes and lines is all a good character requires, but as with all apparently simple things, this is much harder to achieve than it seems.

A good character designer must have excellent knowledge of anatomy and understand how bodies move in order to be able to exaggerate proportions. For example if you want your audience to empathize with or feel sorry for your character, you may want to make the head and eyes larger, which will have an endearing effect.

You must also consider how the character is going to look from different angles, especially if you are designing a character in three dimensions, and make sure that the design will work with the character in different typical actions and poses.

Like writing a script, a character design may go through many drafts until the right look has been captured. Even then it may not animate correctly, so it is important to carry out animation tests, just to make sure.

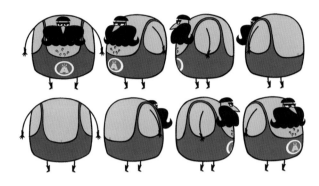

SHAPES

Strong shapes make a good starting point for a character design, and are enjoyable to animate. They can also be surprisingly expressive.

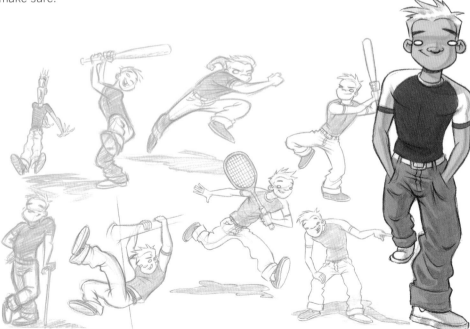

ACTION POSES

In all of these poses of an energetic boy character, care has been taken to reduce the specific action to its essence and then exaggerate it.

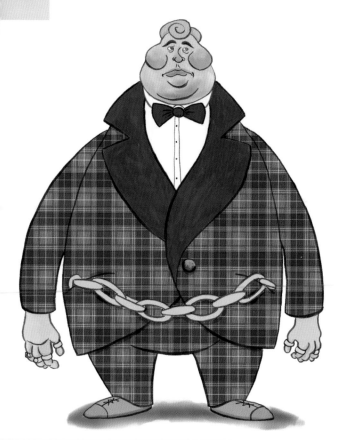

➤◆➤ ECONOMY OF DESIGN

The best characters to animate in both 2D and 3D are always based on very simple designs. The four characters shown here are all very different, and are all remarkably simple but effective in their design. Each figure incorporates a simple shape as a starting point, and minimal detail is added and built up until the character emerges. Sometimes just a simple stylized line or dot is all that is required for surprisingly expressive results.

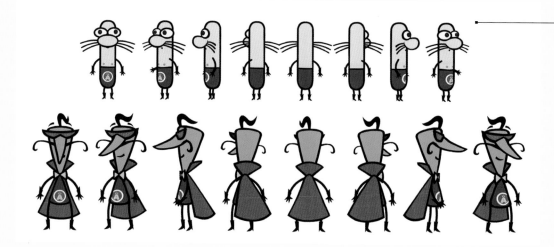

A front, side, and rear view of a character is the minimum number of angles required for a model sheet, but an additional three-quarter view is useful.

➤ THE MODEL SHEET

The turnaround model sheet should contain a character in a neutral pose to enable the modeler to build the character in three dimensions, or the two-dimensional animator to visualize the character from different angles.

► COLOR MODEL
This color model sheet is designed to show the character in a variety of typical poses and expressions so that the modelers or animators can make sure that their poses are in character. Rocket Pig courtesy of Mark Mason Animation.

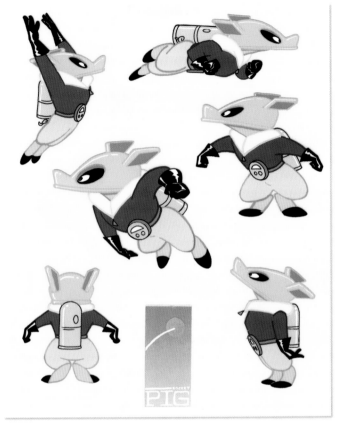

◊ THREE-DIMENSIONAL CHARACTER DESIGN
Once the design has been finalized, the character can be built in three dimensions by using the character turnaround model sheets as reference. The designs can be brought into three-dimensional modeling software as an image plane.

► REALISM
The realistic and anatomically correct human designs found in many anime and manga films are perfectly suited to fantasy and action animation, but less so to cartoon comedy. These characters from Katsuhiro Otomo's 1988 film Akira sparked interest from the West in Japanese animation.

Assignment

Design a character, using basic shapes in its construction. Then see how many poses and positions you can put the character in, and how expressive you can make the character.

See also: Promotion page 134, Selling yourself page 136

CHAPTER 1
Pre-production

Organization

Even the shortest of animation projects involves a small army of artists, technicians, and performers. The person who plans, motivates, and makes it all happen is the producer.

▼ DIGITAL WORKFLOW

With thousands of elements even in a short animation, your file structure must be clear, precise, and logical. Design yourself a file-naming convention that suits the type of production you are working on.

The producer

Once it has been established how the project is going to be funded, the producer will draw up a budget for the project, calculating the costs of crew, materials, equipment, insurance, studio overheads, voice talent, key creatives, and delivery. This is often done hand in hand with working out a production schedule, allocating particular members of the crew to a part of the production over a period of time.

It is also the responsibility of the producer to put the creative team together, in the way a soccer coach would pick his players. This is an obvious skill in itself; not only should the artists be suitable for the job in hand, but they also need to be able to work with other people on the team.

File management

Ten minutes of animation could easily contain over 20,000 elements. This gives potential for total chaos if you don't organize properly.

Computers have made it possible to animate digitally, but the amount of work and number of files you generate is huge, and you must adopt a methodical workflow. For example, if you were working on a film called *Danger Squirrel* and currently animating shot 7 and it was your first take, the file would be called something like:

DS_S7_T1

This file would be stored in a folder called "animation," and you would have other folders for other elements of the film, for example for backgrounds, layers, and props. How you organize the filing system is up to you, but set it up before you start the production, and make sure you (or somebody) spend a bit of time managing it properly. A finished animation will have thousands of files, with many referencing each other. You should also back up your work regularly. Weeks of work may be lost due to a faulty hard drive.

► SERIES PRODUCTION SCHEDULE

A production schedule for a television series or feature film is created by the producer to organize the crew over the time of the production.

Organization tips

- If you are producing your own animation, always plan a schedule and stick to it.
- Always allow some contingency time in your project. In animation, if anything can go wrong, it often does.
- Stick to a methodical process (as outlined in this book).
- Don't start the animation until you are extremely well planned. It will be very difficult to change later.
- Always back up your work onto something like a DVD disk. Hard drives can fail.

	1	2	3	4	5	6	7	8	9	10	11	12	13	14	15	16	XM	AS	19	20	21	22	23	24	25	
* Some Storylines need to be complete prior to production																										
SCRIPTS.																										
Writer 1(4 wks per script inc any re writes)	1	1	1	1	8	8	8	8	14	14	14	14	21	21	21	21			28	28	28	28	35	35	35	
Writer 2	2	2	2	2	9	9	9	15	15	15	22	22	22	22					29	29	29	29	36	36	36	
Writer 3	3	3	3	3	10	10	10	10	16	16	16	16	23	23	23	23			30	30	30	30	37	37	37	
Writer 4	4	4	4	4	11	11	11	11	17	17	17	17	24	24	24	24			31	31	31	31	38	38	38	
Writer 5	5	5	5	5	12	12	12	12	18	18	18	18	25	25	25				25	32	32	32	32	39	39	
Writer 6	6	6	6	6	12	12	12	12	19	19	19	19	26	26	26				26	33	33	33	33	40	40	
Writer 7	7	7	7	7	13	13	13	13	20	20	20	20	27	27	27				27	34	34	34	34	41	41	
STORYBOARDS (3 wks pr board inc rev)																										
Artist 1				1	1	1	5	5	5	9	9	9	13	13	13				14	14	14	18	18	18	22	
Artist 2					2	2	2	6	6	6	10	10	10						15	15	15	19	19	19	23	
Artist 3					3	3	3	7	7	7	11	11	11						16	16	16	20	20	20	24	
Artist 4					4	4	4	8	8	8	12	12	12						17	17	17	21	21	21	25	
VOICE RECORD	cast	cast			1 to 6			7 to 12			13 to 18								19 to24			25to30				
ANIMATIC																										
Editor 1						1		2+3	4+5		6+7	8+9							10+11	12+13		14+15	16+17		18+19	
CHARACTER/LOCATION/PROP DESIGN				1	1	3	3	5	5	7	7+9	9		11	11+13	13			14	14+15	15		18	18+19	19	22
all main characters locked prior to start				2	2	4	4	6	6		8	8+10	10		10	12	12		16	16+17	17		20	20+21	21	24
DELIVERY OF PRE ANIMATION PACK TO STUDIO(NOT BG/LAYOUTS)					1+2		3+4		5+6		7+8		9+10						11+12		13	14	15+16		17	18 19+20
(INC SCIPTS/BOARD/ALL DESIGN/)																										
LAYOUTS																										
Artist 1					1	1	1	5	5	5	9	9	9						13	13	13	14	14	14	18	
Artist 2					2	2	2	6	6	6									10	10	10	15	15	15	19	
Artist 3					3	3	3	7	7	7									11	11	11	16	16	16	20	
Arist 4					4	4	4	8	8	8									12	12	12	17	17	17	21	
BACKGROUNDS																										
Artist 1					1	1	1	5	5	5	9	9							9	13	13	13	14	14	14	
Artist 2					2	2	2	6	6										6	10	10	10	15	15	15	
Artist 3					3	3	3	7	7										7	11	11	11	16	16	16	
Artist 4					4	4	4	8	8										8	12	12	12	17	17	17	
DELIVERY OF LAYOUTS AND BGS TO ANIMATION STUDIO										1				2.3.4.5					6,7,8,9				10 11,12,13			
ANIMATION																										
Animation Team 1 x 6 animators 4wks inc re takes									1	1	1	1	2						2	2	2	10	10	10		
Animation Team 2													3	3					3	3	6	6	6	11		
Animation Team 3														4	4				4	4	7	7	7	7	12	
Animation Team 4														5	5				5	5	8	8	8	8	13	
Animation Team 5																			9	9	9	9				
COMPOSITING / AFTER EFFECTS																										
Team 1																			1	1	1	2	2	2	7	
Team 2																				3	3	3	5	5		
Team 3																				4	4	4		6		
Titles and Credits (needs a mini schedule)		X	X	X	X	X	X	X	X	X	X	X	X	X		X										
MUSIC																										
stings/beds/happy/sad/fast/slow etc						X	X	X	X	X	X	X	X		X	X										
Assembly to picture																						1		3	2	
FOLEY																						1		3	2	
AUDIO POST inc MIX/TRACKLAY/TRANS																							1		3	
OFFLINE																										
ONLINE																										
FINAL DELIVERY																										

| DIRECTOR 83 wks + 5wks spare prior to prod for pre scipt |
| PRODUCER 83 wks + 5 wks spare prior to prod for pre script |
| PRODUCER 78 wks +2 wks spare |
| ANIMATION DIRECTOR 54 wks |
| LINE PRODUCER 78 wks |
| ART DIRECTOR 47 weeks |
| STORYBOARD SUPERVISOR |
| PRODUCTION CO-ORDINATOR 78 wks |
| PRODUCTION ASSISTANT 65 wks |
| SCRIPT EDITOR - 40wks in total - 5 prior to prod |
| EDITOR FOR ANIMATICS - 44 WEEKS |
| EDITOR FOR OFFLINE/ONLINE 54 weeks |

Production

With everything meticulously planned and designed it is time to start the second key stage of the process, production. This is the stage where the characters come to life and the environments become the world in which the characters perform. Good camera and lighting work ensures the film is given the sparkle it deserves.

CHAPTER 2
Production

Animation techniques

There are many digital animation techniques at your disposal. Contemporary animators are mixing up styles and techniques to produce something fresh and original.

Cut-out

Before digital animation techniques were accessible and affordable, cut-out animation was a technique used by independent animators to create animated films. By cutting out artwork and photographs, the animator was able to move and manipulate these images under the camera. Now, with digital animation packages, it is possible to create cut-out animation easily and quickly.

Stop frame

Also called stop motion, stop-frame animation requires the use of a digital camera to record images frame by frame, which are then played back in real time. Objects or puppets can be placed in front of the camera and manipulated by small increments to create the illusion of movement.

Pixilation

The pixilation technique closely resembles stop-frame animation, but instead of models and puppets, the animator utilizes lifesize objects and people.

2D digital

"2D digital" is a very broad description of the style of animation usually referred to as drawn, cel, or cartoon animation. The animator will draw each frame separately either on paper or a digital graphics tablet, which is then colored and composited together with a background. The illusion of depth can be created by using compositing software to replicate the effect of a multiplane camera (see page 105).

3D digital

3D CGI (Computer Generated Imagery) animation involves the use of computers to create geometric data that is then rendered out to create three-dimensional images. Recent developments such as faster processing and render times in CGI allow animators to create both photorealistic and highly stylized animation.

Compositing

Although not strictly an animation technique, creative compositing allows animators to combine visual elements from several sources which are then layered together to give the illusion that the elements are part of the same image, creating an original and unique look. By using compositing it is now possible to easily mix live action, animation, and artwork. (See page 118 for more on compositing.)

Motion capture

A widely used technique that is not strictly animation, motion capture requires an actor to perform while wired up with sensors recording every move. This data is then fed into 3D software and the movement is applied to a CGI puppet that will mimic the exact moves of the performance. A well-known example is the character of Gollum from the *Lord of the Rings* films.

Unusual techniques

There are many different animation techniques, and providing you create or manipulate each image, it can still be described as animation. There are animators, for example, who create great animation by photographing sand frame by frame, others who manipulate oil on glass, and others who experiment with machinery. It is up to you to be imaginative.

For example, cameraless "scratch" animation is an organic and exciting technique that produces some fantastic and often surprising results. The process simply involves drawing and scratching directly onto film celluloid. When projected or digitized the results are raw, but often beautiful, abstract images, which take on a life of their own.

SOUNDSCAPES
Norman McLaren, one of animation's great pioneering artists, would often experiment with scratch animation, not only on the picture, but also on the sound, creating evocative soundscapes to accompany the animation.

SCRATCH ANIMATION
During the 1930s Len Lye worked for the GPO Film Unit in the UK and created some amazing films using scratch animation. The array of color and shapes from this frame demonstrate the energy possible with this technique.

Tips

- Don't restrict your creativity by using just one technique. Some of the most interesting animation around today is a mixture of techniques.

- Experiment... Digital technology for filmmaking has never been so cheap, so try as many methods as possible.

- Push the boundaries of the software you are using. Don't rely on the default look, but make it your own by experimenting.

DIGITAL CUT-OUT
Although highly influenced by Terry Gilliam, the South Park *television series is actually animated using 3D software to emulate Gilliam's cruder cut-out style. Trey Parker and Matt Stone did, however, create the original* South Park *short using traditional cut-out techniques.*

▲ 2D ANIMATION

The simplified shapes of this two-dimensional digital animation combine well with the visual effects, composited onto a live-action background.

► STOP FRAME

Traditional stop-frame animation was used by Linda McCarthy to create the short film Small Birds Singing, *based on Steven Appleby's comic strip. Puppets with maneuverable armatures were animated frame by frame.*

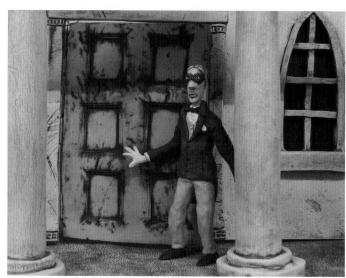

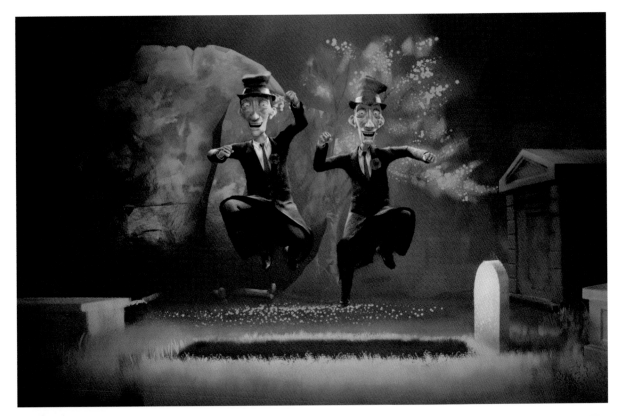

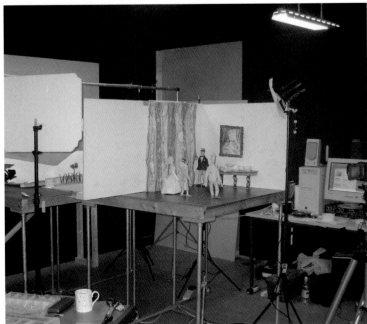

➤ 3D ANIMATION
In their short film This Way Up, *directors Smith & Faulkes combine three-dimensional animated characters with painted environments.*

❢ PHOTOGRAPH MANIPULATION
By using digital cut-out animation software and manipulating photographs, it is possible to produce original characters for animation. This character from the television series I Am Not an Animal, *directed by Tim Searle, was animated in Celaction 2D software.*

➤ STOP-FRAME SET
The set for Small Birds Singing *is a typical setup for a stop-frame animation production. Each frame is captured digitally by computer and then played back in real time.*

Voice recording

Audio is a crucial part of animation, but novice animators nearly always overlook this aspect. Perhaps as visual thinkers they underestimate the power sound has to add to the experience for the audience. However, sound is crucial, and you should get it right from the start.

The voices for animation are usually recorded first, especially if there is any dialog that needs to be animated as lip-synch. Take measures to get the best voices possible, both technically and creatively.

Working with voice actors

The performance of your animation is only going to be as good as the voice performance, so cast an appropriate voice artist. If possible use a professional actor who understands timing and delivery and can act. A good voice performance for animation should be overexaggerated and energetic, particularly if your animation is character-based.

When directing an actor, make sure you give them as much information as possible about the character they are playing, and even show them a design if you can. This will really help the actor to get into character and give you the best performance.

Equipment

If you have the means, you should try to record the voice in a professional sound studio. This will come equipped with all the best equipment and a professional sound engineer. If your budget is limited, you may have to record the voice yourself.

Microphone

The best type of microphone for voice recording is a unidirectional condenser microphone. This will pick up only what is placed in front of it, and not the background environment, and will also respond well to the frequencies of the human voice. Most good condenser microphones will also require a preamp, which powers the microphone and connects it to your

→ UNIDIRECTIONAL CONDENSER MICROPHONE
A unidirectional condenser microphone will pick up the sound from one direction only and is therefore ideal for voice recording. This microphone is mounted on a specialist stand that holds the microphone in such a way that vibrations and unwanted noise are kept to a minimum.

computer. The microphone will need to be positioned at mouth height on a sturdy stand. Choose a quiet environment in which to carry out the recording.

Software

There are many affordable digital recording software packages available such as Adobe Audition, ProTools, Audacity, AVS Audio Editor, and Garage Band (free as part of the iLife package), which will allow you to record and edit. If you prefer, most editing software such as Premier or Final Cut will allow you to record a voice track.

Interview with voice artist Keith Wickham

Keith Wickham has provided the voices for many animated characters shown on television all over the world. Here he gives some insight into the world of being a voice artist.

Q Describe your average working day.

A When I'm not waiting for the phone to ring, I'm in and out of various sound studios, doing all sorts of jobs such as reading instruction manuals for car dealers, television commercials for hair products, or cartoons. I could be practicing a voice or reading a script.

Q What's your process for coming up with the best voice?

A It varies. Sometimes it's instant. You see the character on the page and you know straight away what voice it needs. If the director allows you to play about with it, and most do, you try and find the most amusing as well as the most realistic for that character. Other times you don't know at all, and you try all sorts of different voices.

Q What is the most important thing about voice performance for animation?

A You have to be able to read off the page instantly, provide an accurate and consistent voice or voices, be funny, be energetic, and basically act your way through with as much dignity as you can muster, bearing in mind you're playing a stick insect with a lisp.

Q How does animation voice work differ from other types of acting or voice work?

A From acting, very little. It's an acting job, not a voiceover. The only difference is that there are no rehearsals and you don't have to learn the lines.

For voiceovers, you are generally selling something or reading information; with cartoons, you are breathing life into a character, but with a slightly ridiculous voice.

Q How did you get into voice performance?

A After doing a lot of comedy work in sketch groups and as a stand-up, I sent voice tapes off to about 100 agents. One of them picked me up. At the same time, I got a job writing and performing for a radio series, which put me in contact with a sound studio and a casting director who did loads of cartoons. They heard me doing my voices and I started getting castings. It was, as ever, down to luck.

Q What's the best thing about being a voice artist?

A The freedom, the creative satisfaction, the friends I've made, the vindication that this was the right choice for me. The money can be good, but not as often as outsiders assume.

Voice recording tips

- Don't forget to record extra sounds for your character such as gasps, laughs, sighs, and so on... These will be very useful later on.
- While you should not be afraid to ask for a few alternative takes, trust your actor to give you the right performance, and don't make them retake every single line. Be flexible.
- If possible, use a professional sound studio.
- It is advisable to record your voice before the animation.

→ SUBVERSION
When planning a voice, consider subverting expectations. How about giving a dinosaur a high-pitched, squeaky voice or a mouse a gruff baritone?

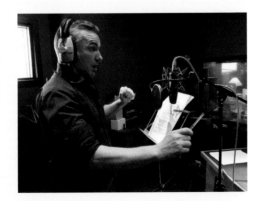

→ VOCAL PERFORMANCE
It may look like he is conducting an orchestra, but here voice actor Keith Wickham is in action performing a dynamic voice for animation. To get into character good actors will need space to perform properly and will probably become animated themselves.

Digital 2D artwork

In addition to character and background design, don't forget the props. You now need to add the detail to your production.

Color models

Once you (or the director) are happy with the look of the film, all the elements need to be designed precisely so the production artwork and animation can be created. Although there may be subtle differences at this stage, depending on the animation technique, you will need to create color models that indicate the exact colors used on each character and their props. The color models should clearly indicate any costume changes, as well as alternative states of the character—for example if the character gets wet, or ill, or something happens to them in the story that requires a design change. It is also common for the designer to create a night palette, should any of the action take place at night.

The color models for stop-frame animation are more like blueprints, with an indication of materials to use in the modelmaking as well as exact measurements. For CGI the designer will include examples of textures and surfaces as well as a detailed turnaround.

If there are a number of characters in the production, it is also advisable to create a cast sheet, showing all the characters lined up to give the animators an idea of the comparative scale of each character (see below).

▼ CHARACTER LINEUP
A character cast lineup gives the production crew clear instructions about the relative sizes of characters. Model sheets are an important part of creating a production bible or design pack.

SADIE　　　PAULA　　　CHUCK　　　SEAN　　　CHARLOTTE　　MICHELLE

► COLOR ISSUES

Be aware that many colors behave differently with different media. For example, many video signals cannot see the subtle differences in reds, and will often oversaturate. Although this is less of a problem with high definition, be aware that colors on most computer screens are more accurate than many television monitors. For the most accurate color reference it is advisable to mark up your artwork with precise RGB values.

Shirt is too "hot"; belt and shoes are fine.

Shirt: RGB values: 75R; 98G; 173B

Skin: RGB values: 247R; 215G; 188B

► ALTERNATE PALETTES

If your production has a scene set during the night, you should give your character an alternative night color palette to use in those shots, so the character will blend in with the nighttime backgrounds.

The expression and clothing remain the same but changing the colors on the clothing and the skin tones creates a different mood.

Shirt: RGB values: 0R; 130G; 192B

Skin: RGB values: 214R; 205G; 216B

2D tips

- Always use a recognizable object as a comparison for the scale of a prop; otherwise the animators may make the object too large or small.

- Most digital media has a "legal range" of color saturation levels. Ensure that your colors do not oversaturate by testing them in the final medium.

- Create a prop list by going through the storyboard and identifying exactly when and where any props and costume changes are required.

- Study color theory to understand the many dimensions of color.

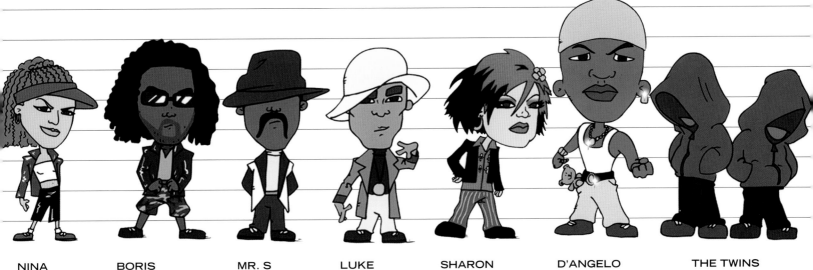

NINA BORIS MR. S LUKE SHARON D'ANGELO THE TWINS

Props

If you were a production designer working on a live-action film, great care and attention would be given to costume and prop design, and it is no different when working in animation. It is important to design, in detail, any props that appear in the production, including vehicles, costumes and accessories, household objects, and food. These props need to sit within the design of the production.

A prop designer needs to have a good knowledge of fashion and product design as well as an understanding of culture and history, as these will often influence the design. You may be working on a production set in a certain period of history, and as a designer you will need to be as accurate as possible. This is when some of your early research material such as mood boards and sketchbooks will be useful.

◊ MODEL SHEET

A model sheet is designed to make sure that the color and design of the character and props are kept consistent throughout the production. Frequently used props can be included alongside characters to give them a sense of scale.

← COSTUME

Even if your characters are highly stylized, you should still ensure your visual research is accurate and the costume design is appropriate for the production. Here we see the Adrenalinis dressed in costumes from around the world. Notice how the character style is echoed in the prop and costume design.

→ REFERENCE MODEL
A turnaround-style color model can be used to identify any particular patterns or textures; props need the same amount of attention. Reference colors by their RGB values to be consistent and avoid any miscommunication among the animation team.

📁 Assignment

Watch a short animation or a scene from an animated feature and make a note of how many props are used in each shot. Note how the design is sympathetic to the general production design.

Now take one of your own character designs and create a detailed color model sheet, one for day and another for night. Design a selection of props and an alternative costume to be used by the character.

Designing props

When designing props to be used by and in conjunction with your characters, consider style, functionality, and essence.

The graphic style of both your props and your characters should be consistent. For example, if your characters are drawn in a "realistic" style, giving them zany cartoon props may look visually jarring.

Ask yourself: Does the prop look as if it could really function? Will the various parts of the prop that need to be handled/sat on/worn by a character match his scale and anatomy?

If the prop that you are designing is based on reality, research the real thing and distill its essence into a drawing.

♦ BASED ON REALITY
Never attempt to wing a design based on an object you know nothing about.

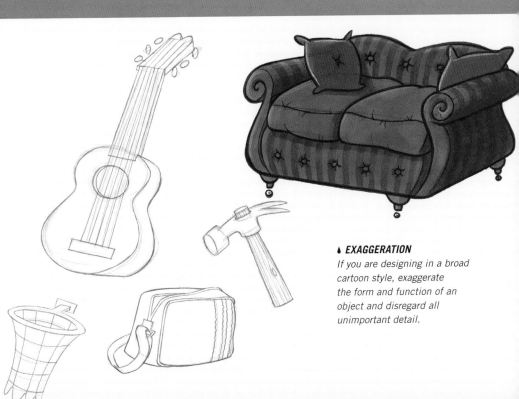

♦ EXAGGERATION
If you are designing in a broad cartoon style, exaggerate the form and function of an object and disregard all unimportant detail.

See also: Character design page 40, Technique and practice page 88

CHAPTER 2
Production

Digital character library

The construction of a well-organized digital character library is essential for any animation production, particularly with 2D elements.

Before digital technology was widely available, cut-out animation involved the painstaking process of cutting out hundreds of separate elements of paper characters—heads, eyes, arms, legs, and so on—filming them under a camera, and storing them in boxes. These elements could easily become damaged, lost, or worn out.

Now, of course, digital technology has made that process much simpler, and there are many animation software packages that allow you to create libraries to store all your character elements digitally. A logical organization of these libraries is critical, as an animated film is made up of thousands of separate elements.

Design an appropriate character

When designing your characters, always consider the animation potential of your designs. Is your character feasible to animate? Many novice animators design wonderful but extremely complicated characters that become almost impossible to animate. For animation character design, the "less is more" rule certainly applies.

Your characters should be easy to split up into separate elements. To get the optimum animation potential, divide the character up into as many separate elements as possible. The more individual elements there are, the more expressive and interesting the animation will be.

Most software will allow you to move the pivot points for your elements. So if you were constructing an arm for a character, you would insert the pivot point at the top of the arm near the shoulder.

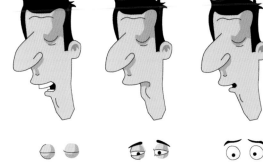

Creating your elements

Once you have designed a character, you can start creating the elements. The elements will be generic elements at first (eyes, mouths, arms, and legs) but will develop as the stories for the character evolve. Most digital animation or editing software packages will allow you to import bitmaps or vectors so your elements can be created in whatever drawing program you are comfortable with or, for traditional purists, scanned-in artwork.

FACT

The first full-length animated feature film was Lotte Reiniger's cut-out animation *The Adventures of Prince Achmed* in 1926, 11 years before Disney's *Snow White and the Seven Dwarfs*.

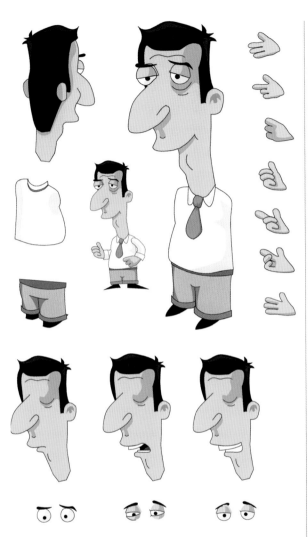

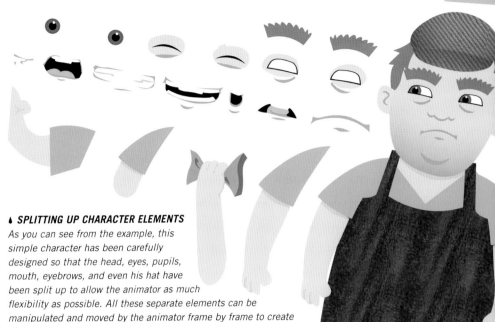

▸ SPLITTING UP CHARACTER ELEMENTS

As you can see from the example, this simple character has been carefully designed so that the head, eyes, pupils, mouth, eyebrows, and even his hat have been split up to allow the animator as much flexibility as possible. All these separate elements can be manipulated and moved by the animator frame by frame to create a surprising variety of expressions and lip synchronization.

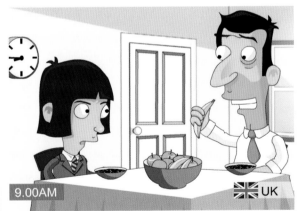

9.00AM

▸ HOW CHARACTER LIBRARIES AID ANIMATION

Here, we see the characters interacting in Gilmerton Heights. Well-built character libraries allow the animators to concentrate on the actual animation, which they should be able to achieve quickly and effectively. Notice that Darren is holding a banana. This would have been anticipated by the character designer, to ensure the animator had access to a hand holding a banana.

▸ COMPILING A CHARACTER LIBRARY

It should be possible to animate a well-designed character into any conceivable position or expression. Notice how the elements of this character, "Darren" from Gilmerton Heights, have been split up.

Library tips

• Label all your elements logically. "Arm_1" is preferable to "Arm_right" for example, because if the character is reversed, right and left will swap.

• Split the character into as many elements as possible. This will give you much more flexibility with the animation.

• Don't rush the design and jump too quickly into animation; this will compromise the final animation.

• Keep your design simple but striking.

• Organize your libraries methodically—other people may need to navigate through them.

See also: Environment design page 36

Backgrounds

Your scene is not complete without a background. This may be a sophisticated three-dimensional backdrop or a simple color design.

In traditional cel animation the characters would be traced and painted onto clear acetate sheets, or cels, that were then placed on top of the background artwork and photographed frame by frame. This was the procedure from the 1930s until the mid-1990s, when digital technology allowed this layering and compositing of artwork to be done by computer. With digital technology the physical restrictions of using cel and multiplane cameras are long gone, and background artists can produce highly intricate and elaborate multilayered artwork.

As well as using paper, background artists now have the option of creating their artwork digitally in one of the many digital paint packages available. Digital art for 2D animation is different from 3D CGI in that it does not involve the creation of a model that requires texturing and rendering. However, you can create the illusion of 3D through clever design. Several two-dimensional planes and layers can be built up to create extremely sophisticated scenery, which to the untrained eye will look convincingly three-dimensional.

Most software can simulate the style of any hand-painted technique, and as an artist this gives you the potential to work in layers, tweak colors, and generally be more flexible in your work.

Whatever style or technique you decide to work in, it is essential that all your backgrounds be kept consistent throughout the production, are believable environments for the action, and most important, do not overpower the action. A good background should make the animation the center of attention, and not distract the eye of the audience.

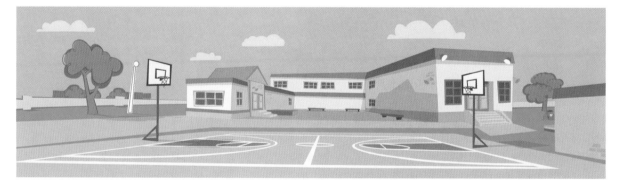

▸ 1950S LOOK

The influence that some of the 1950s classic studios had on animation design is still apparent in current animation design. A contemporary illustrative treatment, reminiscent of the 1950s look, has been given to this background by James Brown of Pixel Pinkie.

Assignment

An important part of a background painter's job is to understand light. For a good exercise, set up a still life in a dark area, shine a strong light on it, and paint what you see, emphasizing the dramatic contrasts of light and shadow that occur. Do this in a traditional background style, using acrylic paint.

Interview with background artist Kathy Nicholls

Kathy trained as an illustrator and originally worked in the editorial and advertising world before becoming a background artist. She has worked on a number of commercials, television series, and award-winning short films. She also continues to work as an illustrator and is writing a children's book.

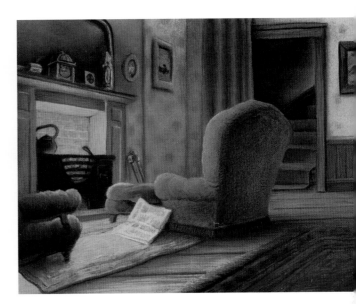

Q What's your process for designing a background?

A *On a large production the design of the backgrounds is a collaboration between several people. Using the storyboard as a blueprint, a layout artist would do a bigger, more detailed pencil drawing of the background on animation paper. This layout was then passed to me to turn into a production background. The layout was usually an outline of the composition and often contained some information on how to light the background.*

Q What is the difference between designing a background for animation and illustrating a picture for a book?

A *Although some backgrounds look like illustrations, there is an essential difference. A background is a kind of stage waiting for its character to enter; they can often even look like a stage set with a soft light where the focal point should be.*

Q What are the essential skills a background artist should have?

A *Versatility, an understanding of light, good painting skills (of course). A sensitivity to color and a knowledge of how to create deep space, where landscapes recede into the distance. As with all jobs in animation you're serving the story that's being told, and there are hundreds or thousands of pieces of artwork all doing that same thing. You learn not to be too precious about your work.*

Q Who (or what) is your inspiration?

A *As a background artist you can become very inspired by the subject that you're working on. For example, if you're doing lots of riverbank foliage, as I was on Angelina Ballerina for a while, you can't stop looking at trees and the contours of bushes to see how the light falls on the various shapes and colors of the leaves. At times it can become almost obsessive, turning a nice walk in the park into hard work. I also love to look at the work of a variety of artists and illustrators and try to understand their working techniques, particularly old masters such as Rembrandt and Rubens.*

Q Do you have any tips for new background artists?

A *Do lots of drawing from life in your sketchbooks: Good drawing skills are the basis for many of the jobs in animation. When you're feeling confident about your painting skills, ask if you can do a test for a current production; you won't get paid but you'll learn a lot from doing it and they may see promise in your work or even employ you.*

Q What's the best thing about being a background artist?

A *It's a pleasant job and you're part of a team working toward a common goal, and it's a big thing that you're doing together, so much bigger than anything you can do by yourself. When the film is finally screened it's very exciting to see the part you played, in its final context.*

Q And the worst?

A *The working hours, the commitment, and the intense concentration are hard to fit in with a young family.*

◊ TRADITIONAL PAINT EFFECT

Background artist Kathy Nicholls used traditional painting techniques to produce this atmospheric background piece. Attention to detail was required for the room furnishings. Note how, through the use of light and color, your eye is drawn toward the fire.

Tips

- If you prefer to create your backgrounds traditionally on paper, ensure that you scan them to about 600 dpi on a high-quality scanner, or use a good digital camera.

- Make sure you work from layout drawings. You don't want to paint anything where the action needs to take place.

- Experiment with styles and colors.

- Don't overcomplicate the background— remember to allow space for the action.

See also: Film language page 28, Lighting page 112

Staging

A crucial part of shot design is staging or choreographing the movement and characters so that the purpose of the shot is clear.

Our eyes scan images to "read" them in the same way that we look at a magazine or book. As a viewer, we look for clues that give us an idea of what is being communicated in a shot, which could be an emotion, a gag, some action, or a sense of drama. If the idea is not clearly apparent, then the viewer will become confused or disoriented.

Motion
The eye is always drawn toward movement. This could be a simple eye blink or a more defined action. Never add any movement in a shot that may distract from the center of attention, although conversely, if everything is moving in a shot, the eye will be drawn to anything that isn't moving. It is crucial that you not make your shot too busy by having several things moving at the same time.

Composition
The eye is drawn into the scene by the way elements are positioned. A Western audience tends to scan the image from left to right, so objects on the left can appear to dominate. You can frame your focus point using characters, props, and scenery, as well as depth, focus, and lighting. Remember to use 3D space, the camera angle, and perspective to your advantage.

Character choreography
Pose your characters in interesting and non-symmetrical positions. When there are several characters, position them so they are not obscuring each other, and use the space as if you are positioning them on a theater stage. Limit front-on and side profiles, as characters look more engaging from the three-quarter view. The mood and emotion of the shot should be clear from the way you stage your characters.

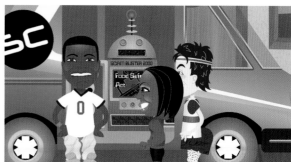

♦ SPOTTING THE PROBLEMS
Here is a shot that has some staging issues! There is no center of interest, the character in the foreground is obscuring another character's face, and there seems to be an issue with her scale—surely she should be bigger? Be careful when using text, as our eyes naturally want to read it and may miss important action.

♦ FINDING A CENTER OF INTEREST
The center of interest in this composition is the flower. Here's why: Our eyes enter the composition from the left and follow the woman's arm and focus on the flower, pausing to explore the child who is giving it. Our eyes then progress to the right, noticing the other two characters. The staging is clearly around the child and woman on the left. The center of interest is clarified by the characters all looking toward the child and flower.

FACT

Charlie Chaplin famously said that in staging a scene he needed only a park bench, a cop, and a beautiful girl to make a comedy.

 ## Assignment

Watch any live-action movie and pause at any shot. Sketch the shot, paying attention to where the center of action is, where the camera is positioned, where the actors are positioned, how the lighting helps the mood, and how, if there are any, the props are being used by the actors.

Staging tips

- Use props to help character and personality, such as a character holding a bunch of flowers.

- Avoid symmetry. The shot will be more interesting if the character is slightly off-center and has an interesting pose.

- Avoid staging too much action in one shot. Split into separate shots if possible.

- If you want to emphasize a character's struggle, have them moving across screen from right to left. This will go against the natural way the audience reads the shot (at least to a Western audience) and subconsciously feel uncomfortable.

- Imagine your character in silhouette. Is it obvious what they are doing?

- There is no such thing as a standard camera angle. Position your camera to the most appropriate angle for the shot and psychology of the situation.

- Don't add drama to a scene that isn't dramatic.

- Allow space around your characters for acting to take place.

⬥ AWKWARD STAGING
The staging in this shot is wrong. The character has no space to point "into," and it feels awkward to look at.

⬥ REVISED STAGING
Simply by thinking about staging, you can create a much stronger composition. The character now has space, and the gap between the character's pointing finger and the edge of the screen is comfortable.

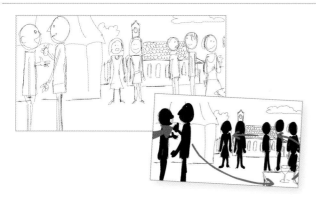

⬥ A BADLY STAGED SHOT
There is no center of interest and we do not know what to look at. Let's suppose we are trying to draw attention to the characters in the center of the frame. Why don't they stand out? Exploring why the staging is bad, our eyes come into the shot and stop as soon as we see the characters on the left who dominate the composition. Our eyes then scan to the right, and finally to the two characters in the center.

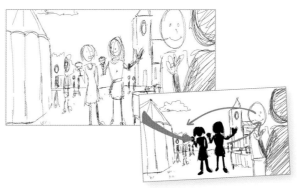

⬥ REARRANGING THE ELEMENTS
By thinking about the staging you can rearrange the same elements and make the viewer focus on the two characters in the center. Our eyes are drawn straight to the characters in the center, as there is nothing of significance obscuring them. The characters seem to have more space to act and are standing at three-quarter views rather than front-on.

See also: Motion page 84

CHAPTER 2
Production

Motion theory

Animation is not simply the process of moving things; it is the art of bringing inanimate objects to life.

Animating is a precise craft that requires practice, perseverance, and a certain amount of natural flair. Animators are the actors of the animation world—literally breathing life into what would otherwise be inanimate, giving the characters personality and believability. Whether 2D or 3D, the theory and principles of animation are exactly the same. Animation using computers is no easier than animating with pencils or clay; in fact, it is probably more difficult.

No two animators work in the same way; they develop their own techniques, and are often brought onto a production because of their distinct style, in the same way particular actors would be cast in a movie for their unique talent in portraying a certain type of character.

An animator must be a great observer of subtlety, and needs to understand anatomy and have an awareness of the laws of physics. A simple facial expression such as a gently raised eyebrow will often say more than any dialog, and it requires a good animator with sound observational skills to make that work. Anatomy is important to an animator in making sure the characters move correctly; even cartoon characters have to have physical restraints within their skeletons so we accept them as real. Of course a cartoon character can stretch and twist abnormally if required, but if arms bend the wrong way, feet twist strangely, or a head swivels through 360 degrees it will still look wrong.

❢ DIGITAL IS JUST AS HARD
It is a myth that by using a computer, animation is somehow made easier, quicker, and cheaper. Wrong! Of course computers are able to cut out some of the menial repetitive tasks, but good animation still requires the patience and skill of an animator, working frame by frame.

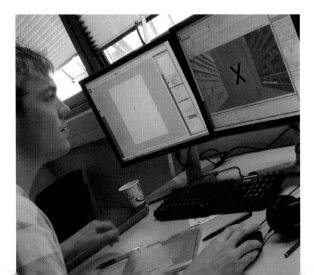

Nailing the timing

If you want a starting point for your animation, why not video yourself acting out the sequence you want to animate? This method is used by many animators and directors and is highly recommended to ensure good timing and performance. The video footage can be used as a guide for the animation, and is particularly good for spotting subtle actions that you may not have considered otherwise.

► THUMBNAILS

Whatever technique of animation you are using, you should always sketch out your action with the key poses on paper before you start animating. These can be very rough scribbles and will be used only as reference.

An animator must also consider the laws of physics. Of course, as an animator, you are perfectly entitled to break these laws, but you should understand them first. For example, when an object falls from a tree, the laws of physics dictate that the object should fall directly to the ground with the correct increasing velocity. If the object floats down, goes off in any other direction, or remains in midair, it would be physically wrong, and would require the skill of the animator to break these rules for dramatic effect. Chuck Jones would often hold the Wylie Coyote in midair, even after stepping off a cliff face, just for a few frames to exaggerate the fall.

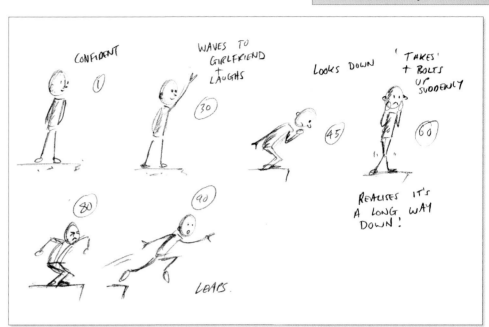

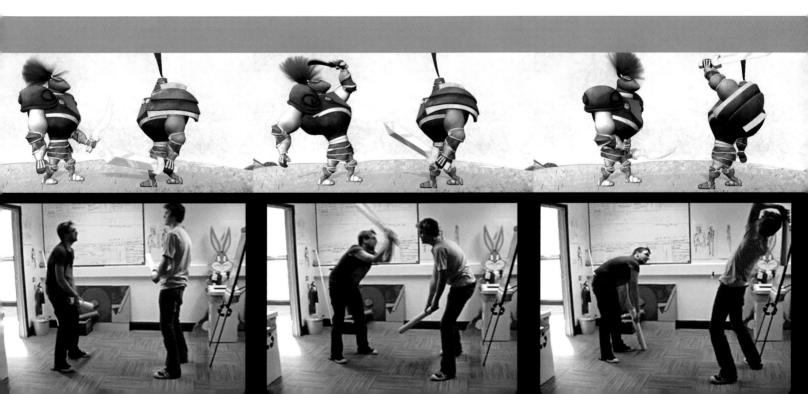

Planning the shot

If you have a scene or shot to animate, refrain from jumping straight in and starting the animation. You need to plan the animation and ask yourself certain questions.

- **What is the motivation of the character?**

Characters should always have a reason to move. If there is no logical reason to move the character, then don't!

- **What is the personality of the character?**

Before you can even consider the animation, you need to understand the personality of the character. Like an actor, you need to get into the spirit of your performance.

- **Observe and interpret.**

Video yourself performing the action and then analyze the movement frame by frame, sketching out potential key poses that make up the core of the action.

- **Plan the key poses.**

Once you have decided how you are going to perform the action, sketch out thumbnail drawings of the key poses and, using a stopwatch, work out the rough timing between each pose. This should be done for any animation technique.

- **Stage the action.**

Use perspective and space to make your animation as dynamic as possible.

- **"Rough out" the animation.**

You should always test your animation at a draft stage to make sure your timing and poses are going to read correctly. If the animation looks too busy, take out some poses. The beauty of digital animation is that poses can be reworked and tweaked until the animation "breathes."

You can see your previous drawings by "onion skinning."

The drawing window allows you to digitally draw and ink your animation.

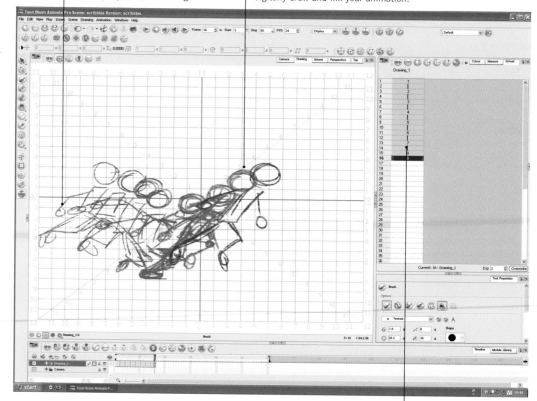

The exposure sheet controls the timing of the animation.

▲ DIGITAL 2D

Using digital software to animate in 2D requires all the same skills as animating using traditional methods. Most 2D software allows you to scan in animation drawings, or if you wish to be entirely paperless then use a digital graphics tablet to draw directly into the computer.

► BUILDING 3D ANIMATION

Throughout a sequence of animation, the animator needs to be aware of the external forces of physics that can affect the character's action. The animator is an actor, craftsman, and scientist all in one.

Main control window where you
can manipulate your characters

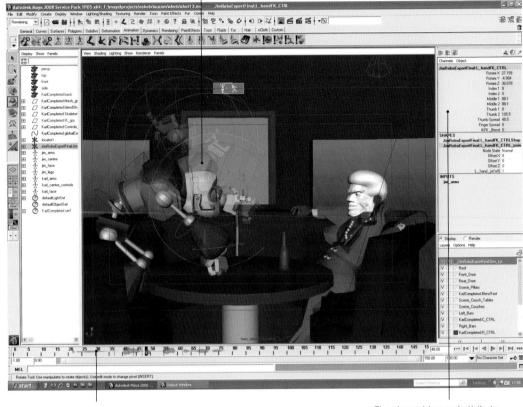

→ DIGITAL 3D

*Animating in 3D is the digital
equivalent of animating using puppets,
and as in stop motion, models have to
be built and rigged before they can be
used for animation. Although if
required the computer will assist the
animator in producing the in-between
frames, the animator is still required to
pose and time the character to make
the animation perform correctly.*

The time slider bar that
scrubs to a particular point
in the animation

The channel box and attribute
editor that allows you to control
your object properties

See also: Anticipation page 74

Stretch and squash

To create fluid and energetic animation, one of the most fundamental principles of animation when working in 2D or 3D is stretch and squash.

When animating a character or shape, a common mistake for beginners is to end up with some animation that looks wooden and rigid. As the job of an animator is to breathe life into otherwise inanimate objects, as opposed to simply moving shapes from one place to another, there are many basic principles to give your animation life and energy. One of these key principles is "stretch and squash," which is literally stretching and squashing whatever you are animating to exaggerate the movement and give the illusion of life.

Stretch and squash can be applied to any shaped object or character, and helps the animator make the animation look more believable, giving it weight and integrity. The amount of stretch and squash you apply to your animation will depend on several factors.

- What substance the object you are animating is made of—a rubber ball will require more than a solid bowling ball, but any object will require some amount of stretch and squash.
- The weight and mass of the object you are animating—a bag full of sand will behave totally differently from a bag full of feathers.
- The speed the object is traveling—the faster the object is moving, the more stretch you can apply, and, upon impact, the more squash.

► WATCH IT BOUNCE!

If you were to watch the first sequence (Illustration A) of the ball animating, it would look stiff and lifeless. No one would believe that the animation was a ball.

If, however, you were to watch the second ball (Illustration B), where the animator has carefully stretched the ball as it falls, and squashed the ball as it hits the floor, it would look more fluid and believable. Illustration C extends this idea further.

Illustration A

Movement tips

- Watch that the volume (or area) of your shape remains the same—see below.

- Obey the rules of physics! If you want to animate a realistic bounce, the shape should come to a natural and believable stop, with a "slowout" or deceleration.
- Try to anticipate stretch and squash in a 3D rigged model by allowing the model to be as flexible as possible—there is nothing worse than trying to animate a rigid model.
- Observe real objects moving—film them with a camera and watch through frame by frame.

 Assignment

If you are working in 3D, make yourself a simple ball. Animate three types of ball bouncing into the shot and coming to a halt: a Ping-Pong ball, a basketball, and a bowling ball. Think about and apply the principles of stretch and squash and see how it affects your animation.

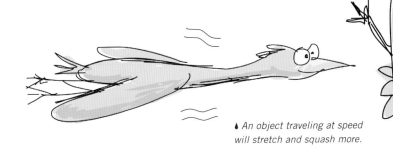

🔹 *An object traveling at speed will stretch and squash more.*

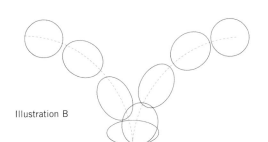

Illustration B

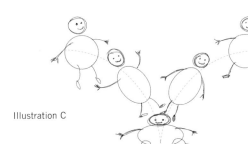

Illustration C

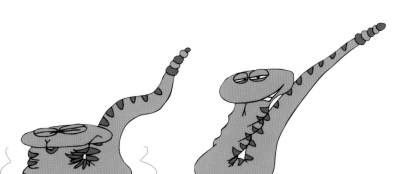

➥ *The weight and mass of the object determines how much stretch and squash is applied, as demonstrated in this example.*

See also: Stretch and squash page 68, Overlapping action page 72

Timing and weight

You need to have a good understanding of the key animation principles in order to make your animation dynamic and fluid.

Timing

This is something that will improve with practice and is the area where all novice animators struggle. Timing is as important to an animator as it is to an actor or musician. Imagine, for example, a musician who had no sense of timing getting all the right notes but with no "punctuation" or accents on certain notes. A piece would be dull and unrecognizable.

Like a musician, an animator must practice timing. Eventually the accents and punctuations of movement will begin to flourish and your animation will appear more dynamic, energetic, and fluid. A stopwatch should be an essential part of your equipment. Start observing movement and timing how long things take. A simple arm movement will look completely wrong if it is too fast or too slow.

It is also important to understand how long you can hold poses before moving on to the next pose. If you animate from pose to pose too quickly with no pauses, the action will look frantic and the audience will miss the performance. If, however, you leave too much of a pause between poses, the action will look wooden and robotic.

Weight

Different objects will move differently according to their weights. A beach ball, although similar in size to a bowling ball, will have completely different properties, and it is the skill of the animator that gives the object those properties in an animation.

Weight is something that will affect every single thing you ever animate. Weight defines gravity, volume, and character, and without these attributes your animation will look unconvincing.

Imagine that you have been set the task of animating a giant dinosaur. Every footstep will require the transferring of massive amounts of weight from one leg to another, and if this does not come across in the animation, it won't convince the audience.

◂ STOPWATCH

A stopwatch is a vital tool for an animator to help give you an idea of timing. You will often be surprised by the length of time (long or short) that some actions take.

◂ COMING TO A STOP

All objects have weight, and the laws of physics state that everything has a momentum. This means nothing stops suddenly without easing to a halt, as illustrated here. Position 3 is the halfway point between positions 1 and 12, but due to the ball decelerating there are a further eight positions in between, diminishing distances apart. This theory of easing in and out applies to most animation situations, and will help give your timing a sense of weight.

1 2 3 4 5 6 789 12

Assignment

Using a simple figure, animate a series of actions where a character is lifting up different objects such as a large heavy box, a light empty box, a heavy sack, a beach ball, and a gold bar. Pay particular attention to how the weight of the object affects the body. You may want to video yourself performing these actions to analyze the movements.

► WEIGHT IN 3D
Conveying weight in 3D uses exactly the same principles as in 2D but you may find that your model "breaks" in certain stretched positions. Make sure that you fully test the model before animating to ensure it will bend into some of the more extreme positions required for suggesting weight.

Timing tip

One of the secrets of good timing is simplicity. Avoid overanimating the action—animate just enough to make the action "breathe."

◊ CONVEYING WEIGHT
Every object has a weight, and for your animation to look believable you need to convey that weight convincingly. A feather and a brick obviously have different weight attributes and, when dropped from a height, will fall differently. Whereas the brick will plummet and hit the ground with a thud, the feather will float, taking more time, and therefore more frames of animation.

◊ CARRYING A WEIGHT
An object will be made to look heavy only by the way you treat it in your animation. The object the figure is carrying in the first drawing looks light because of the way the figure is relaxed and neutral. The object in the second drawing, which is exactly the same size, appears heavy due to the way the figure is holding it. The weight of the object is emphasized by the figure's arched back and attempt to counterbalance the object's weight.

◊ PUSHING POSE
This figure is pushing a heavy object. We know this because of the way the figure is posed with arms and spine locked straight, exerting all its pressure onto the object, and the enormous conflict of the object resisting movement.

See also: Anticipation page 74

CHAPTER 2
Production

Overlapping action

All animators want to avoid having their animation look dead and lifeless. Overlapping is a simple principle with an effective result.

Overlapping action, or "overshooting" as it is sometimes referred to, is an important principle that helps you give your animation weight. If your character or object stops suddenly (with no overlap) it will appear to have hit an invisible wall.

The best way to overcome this is to always animate beyond your final position and then bring the object back. How far you overshoot depends on the speed, weight, and substance of the object.

Parts of your character may require stopping at different times, and this is fine. A character's arm, for example, may overshoot farther than the main torso, and any loose clothing on that arm will overshoot even further. This will all give believability to your animation, in terms of weight.

Some form of overshoot should be applied to nearly all animation situations, however small and insignificant the action may appear. Even a simple head turn will look more effective if you take it just past the last position and back again.

Secondary animation
When a character is moving, there are many dynamics of movement that respond to the pace, direction, and laws of physics. A perfect example of secondary

◢ STOPPING AN OBJECT WITH MOMENTUM
Overlapping action is an effective principle in animation, and is used when an object traveling with some momentum comes to a halt. Rather than have the object stop dead, it is good practice to overshoot the final position, as shown here. The pendulum swings in through positions 1 and 2, but rather than stop at the final location, it swings to position 3, and then back to the final place, 4.

animation would be long hair. Although the hair has no ability to move on its own, it is constantly dynamically responding to the movement of the head. When the head stops moving, the hair will continue to move under its own momentum, overshooting the final head position, and then as the momentum slows down, the hair will fall back to its natural position. The hair may swing backward and forward a few times until it comes to a natural stop.

1 2 4 3

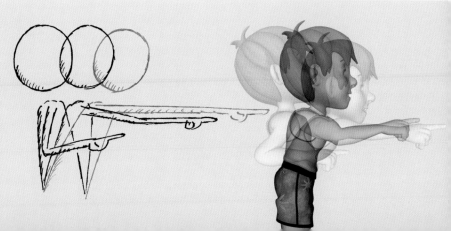

◄ OVERLAP THEORY IN ACTION
Here you can see overlap theory in action, with an extra, more extreme, pose added into the sequence, overshooting the final position. With a pointing action this can be exaggerated because it is a fast movement, but overlap should apply to most animation situations.

◆ EMPHASIZING SPEED

Overlap can be applied to any situation where a movement comes to a stop. The animation of this car coming to a halt will look much more believable with an overshoot at the end of the sequence; also note the way the car is skewed forward when moving to emphasize its speed.

➜ SECONDARY OVERLAPPING

Long, flowing hair is a good example of secondary overlapping animation, and presents a particular challenge to animators. As the torso and head moves forward, the hair will continue moving even when the body has stopped, and its own momentum will continue to make it swing backward and forward until it stops naturally.

Overlapping tips

• Overshooting the action is good practice, but be careful not to overanimate. As with many of these principles, used carefully it will add life to your animation, but if overused it will look like too much.

• Overlap should be used in conjunction with other principles, notably stretch and squash (see page 68).

• With experience you will gauge how much overlap a movement needs. The faster and heavier the object, the more overlap you will need.

◆ ACHIEVING SUBTLETY

Try using overlap to achieve more subtle animation. In this example of a head turn, the character overshoots the final position for a few frames and settles back to the final pose. These subtle uses of overlapping action are very rarely noticed by the audience; in fact if they are noticed, it is usually a sign that you have overanimated!

This action exaggerates the overlapping movement of the animation and can last much longer than the actual action itself.

As a digital animator, you are able to employ certain dynamics applications which claim to carry out secondary animation for you, but be very wary of these. Top professional animators will never use these applications for the principal action but may use them for characters in the background, or on crowd scenes.

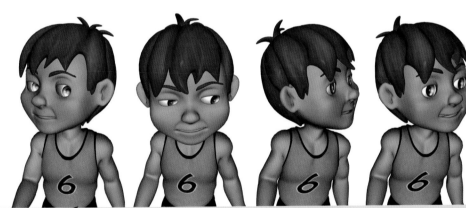

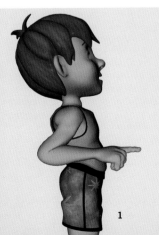

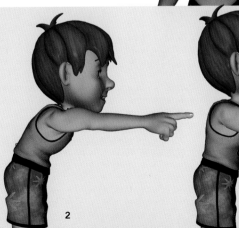

1 Breaking down the key positions, we see that the first pose in this sequence is a reaction pose where the character is tensed up, ready to point.

2 The second pose is the overshoot, which has gone beyond the final position.

3 The third pose is the end position, which feels like the most natural posture for the character. If the overlap were left out from this sequence when animating, it would look flat and mechanical. Overlap gives your animation bounce.

1 2 3

See also: Stretch and squash page 68, Overlapping action page 72

CHAPTER 2
Production

Anticipation

Newton's third law of motion states, "For every action there is an equal and opposite reaction," and this is the key to the next animation principle, anticipation.

The basic principle of anticipation is that before every action there is a subtle movement in the opposite direction. This may sound odd but without anticipation, your animation will look lifeless and mechanical.

Think about your own body when you want to move, say for example to throw a ball: You will twist your body back, hold the ball behind you, perhaps bend your legs, and coil up like a spring—"anticipating" the throw. You will then exert your energy and throw the ball, bringing your entire body forward and making the ball accelerate into the air. Without that anticipation, you would not have had the power or momentum to throw the ball. This is the theory that should be applied to all actions, no matter how small. The bigger and more powerful an action, the bigger and longer the anticipation pose should be.

As an animator you can have fun with anticipation, as these are the poses that have the most energy and exaggeration. Think of the way a cartoon car zooms off from the traffic lights, rearing back and squashing up before speeding off. When used subtly, anticipation puts a little bit more emphasis on the action. For example, a character that needs to turn their head will animate much better if the animator makes the head turn momentarily in the opposite direction before the head turns. Although you should always use anticipation in your animation, it is possible to overdo it and overanimate the action. The amount of anticipation you use depends on the power and speed of the move, whether the move is happening from a still position or mid-action, and how much of the body is involved.

⬧ JUMPING
For a jump to work successfully, a combination of stretch and squash and anticipation is required. Starting at pose 1, this figure squashes down into the anticipation pose (2), in the opposite direction to the jump (note how the secondary animation on the limbs aids balance and adds dynamism to the poses), and then leaps into the jump (3–4), assisted by some stretch on the figure.

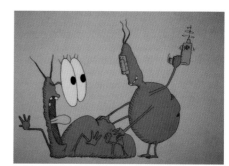

⬧ SURPRISE, SURPRISE!
Big eyes on stalks, the huge expanded mouth, and large tongue are all hallmarks of the cartoon exaggerated double take, but can affect any part of a character's anatomy. It is quite possible to do an extreme take in 3D, but you have to make sure you are able to distort the model before you start the animation. How long you can keep this pose depends on the pace of the animation, but these poses can normally be held (not frozen) for at least 18 frames.

→ ANTICIPATION IN ACTION

Animating an object the opposite way for a few frames before it moves off in the correct direction will improve the animation. How much you move it back by and for how long depends on the weight and speed of the object. In this example, the figure starts at neutral position (1) before rearing back into the anticipation pose (2), then accelerating off (positions 3–5). Note how the anticipation is assisted by the secondary animation in the head and the limbs.

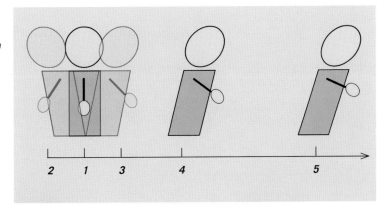

▼DOUBLE TAKES

Anticipation principles are used to the full in the double take. This is the animation technique of having your character glance casually at something, then reacting with a big anticipation and an even bigger exaggerated pose.

1 A double take will have far more impact if you add an anticipation pose between your two key poses.

2 For a take you want to scrunch up your facial expressions on the anticipation as much as possible...

3 ...which will help exaggerate the final expression.

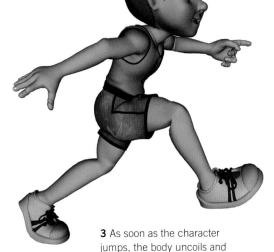

3 As soon as the character jumps, the body uncoils and the energy is released.

1 Anticipation should be used before any movement; the bigger and more dynamic the movement, the bigger the anticipation should be. Anticipation can be compared to a coiled-up spring about to be released.

2 This pose shows the body twisted around the opposite way to the action, the arms coming around the front of the body, and bent legs ready for action.

Tips

• The principle of anticipation applies only to living creatures. Inanimate objects are unable to move of their own accord and will therefore not anticipate movement.

• Think of anticipation in terms of a coiled-up spring about to release its energy.

See also: Body language page 78, Expressions and lip-synch page 80

Performance

Breathing life into your character animation requires a good understanding of acting and performance techniques.

Emotion

As an animator you must understand your character, so you can convey all the traits of that character in your animation. This is not easy and is really dipping into acting theory, but there are a number of fundamental principles of acting that also apply to animation.

First of all, you must create empathy so that your audience can relate to and care for the character, and emotion is a key part of this. If you can make your character appear to think before any action, this will help make the character appear believable—if the character is thinking, surely he or she must have feelings and emotions.

Every action you animate should be a reaction to an action. If there is no motivation for the movement then why does the character need to move? If we hear knocking at a door off-screen, we expect the character to react in some way, but how you animate that movement depends on the situation and the character. For example, a fugitive criminal will react in an entirely different way from a woman waiting for her lover. These are motivations that create emotions and empathy.

Exaggeration

A useful device available to animators (and actors) is exaggeration. Early silent-movie stars were masters of using exaggeration to convey emotions without using any dialog. You can learn many animation lessons from early cinema. The genius of stars like Charlie Chaplin and Buster Keaton was that they were able to tell moving stories, and not only make the audience laugh, but also make them cry.

In animation you are not restricted by physical constraints, and animators will often exaggerate action to emphasize emotion. Animation without any exaggeration would look rather flat. This is why rotoscoped or motion-capture animation can look lifeless, unless the actor exaggerates every move.

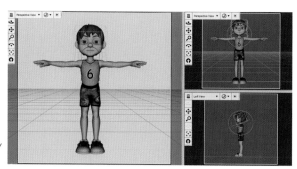

► BRINGING A CHARACTER TO LIFE
Before the animation begins, a 3D model is a rigid and neutral object, and it is the skill of the animator that breathes life and soul into the model. By grabbing and moving various parts of the model, frame by frame the animator builds up a gradual performance.

◖ WHO, ME?
When reading a character, an audience will first look at the eyes and then scan the rest of the body for clues to see what the character is trying to convey. This pose may be familiar to parents or older siblings!

◊ SLAPSTICK

Animators owe a great deal to the pioneers of silent cinema. Exaggerated poses, ridiculous situations, and slapstick melodrama are the DNA of both forms.

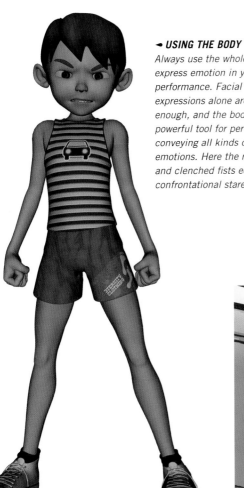

➤ USING THE BODY

Always use the whole body to express emotion in your performance. Facial expressions alone are not enough, and the body is a powerful tool for performance, conveying all kinds of complex emotions. Here the rigid body and clenched fists echo the confrontational stare.

◊◊ SHARING EMOTIONS

Like the early screen performers who realized they could make audiences laugh and cry, animation has the same kind of emotional power. You must allow your characters to share all kinds of emotions with the audience.

Tips

- It thinks, therefore it is. Always make your character appear to be thinking so the audience can empathize with it.

- You must captivate and appeal... otherwise who cares?

- Give your characters the strongest poses possible.

- Always act out the poses yourself first.

- Avoid symmetry like the plague!

Body language

There is one universal language that everyone speaks fluently, and that is body language. As an animator you need to be a first-class body linguist.

Until your character moves, it is just a motionless puppet waiting for you to bring it to life. As soon as you give your character a pose, you are dictating how that character feels by giving the audience clues through the character's body language. A slumped pose with head drooped and arms dangling will convey an emotion of sadness, while an upright stance with arms folded conveys a more positive and confident emotion.

It is impossible for a person to do nothing. A person standing in line waiting for a bus is not doing nothing— he is thinking about his girlfriend; he is trying to avoid eye contact with the thug in front of him; he is trying to remember if it is his mother's birthday... Many conflicting emotions will affect the way he stands.

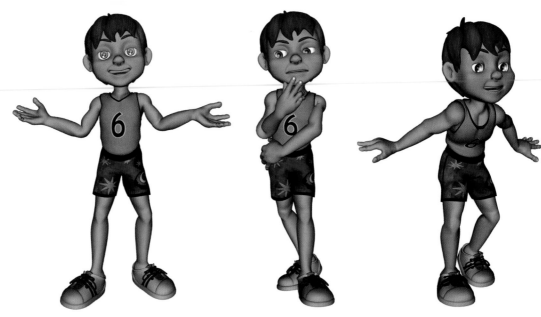

OPEN POSTURE
The open posture can be used when you want your character to appear positive and engaged. This pose (often used by politicians to convince us they are honest) is characterized by open palms, and arms and legs apart.

CLOSED POSTURE
The closed posture, where the limbs are crossed, indicates a more negative and defensive emotion. The character's gaze will often avoid eye contact with another character, suggesting suspicion or insecurity.

FORWARD POSTURE
The forward posture demonstrates that a person is actively interested and engaged in a situation. They may or may not agree with the situation, and could be more aggressive than shown here, but they will be listening intently. To animate this pose, literally lean your character into the action.

If you can convey what your character is thinking and feeling in your pose, that is a great start. You should avoid relying only on facial expressions to convey emotion—the strongest body language is communicated through body stance, and the face should be used to confirm that emotion.

People are extremely good at reading body language, and, as many of the signals are very subtle, it can be difficult to capture these in your animation.

📁 Assignment

With a friend, make two sock puppets and act out some "scenes" with them. Cast one puppet as the dominant character and the other as the submissive character. This will demonstrate that even with no limbs or facial expressions, it is still possible to "act" and be very expressive.

Body language tips

- Take up acting classes or at least try acting in front of a mirror.

- People-watch. Observe how people give off body language signals in everyday situations. A good place for this is a busy railroad station or airport.

- There is no such thing as a neutral pose. People (and animals) are always thinking about something, and their pose will reflect this.

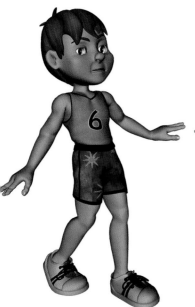 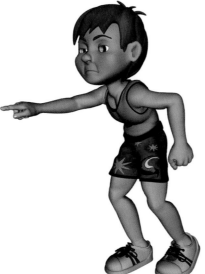 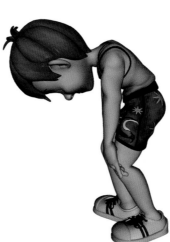 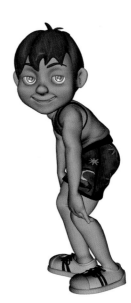

BACK POSTURE
The back posture indicates suspicion and distrust of a situation, and the character is literally backing away. This is still a confident posture and the character is sure of himself, but he simply does not want to get involved and would rather ignore the action.

AGGRESSIVE POSTURE
With an understanding of the four basic postures, you can create more specific poses. This aggressive pose is emphasized by the combination of an open (positive) and forward (actively engaged) posture. A clenched fist highlights the tension.

DEPRESSED POSTURE
It doesn't take a psychic to read the body language of this pose! The slumped body and drooping arms signal apathy, and with the head facing the floor, the character is showing no interest in his surroundings and therefore looks depressed.

CONFLICTING SIGNALS
Body language is far stronger than facial expressions when conveying emotion. Although the face reads as happy, the strong body language of the pose completely overrides it, and so this poor fellow is still depressed, even though he is trying to hide it.

See also: Performance page 76, Body language page 78

Expressions and lip-synch

Facial expressions are the means by which we communicate, and in order to animate emotion and put voices to characters you need to understand how the face works.

A face can make millions of different expressions, conveying complex human emotions. As an animator you will want to give your character expressions that are appropriate to the performance or action. To do this you will have to simplify the face.

Study how facial expressions work by watching great actors or by looking in the mirror at your own face. Then try sketching some of these expressions to see if you can capture the essence of what makes up an expression. You can be surprisingly simplistic in your design and still be incredibly expressive; a good example is the characters from *South Park*, who are able to portray all kinds of emotions from very simple designs.

The focal point for any expression is the eyes. When looking at other people, we usually look into their eyes for confirmation of emotions, and it is always the first place an audience will look when confronted with a close-up of your character. If your eyes behave strangely, it is the first thing that will put off an audience.

The eyebrows and mouth are also fundamental in communication and facial expression and, used in conjunction with the eyes, are very useful in helping you to convey subtle expressions.

Dialog
Most animators prefer to wait until they have animated their character's body language and expressions before attempting the mouth shapes. Animating lip-synch is not about simply opening and closing the mouth; it requires carefully matching up mouth shapes with the sound—in other words, synchronizing the lips.

How many mouth shapes you have depends on the design of the character. Some animators may use just three or four, whereas others use dozens, but as a rule you should have a minimum of eight mouth shapes that will comfortably cover most of the sounds made by speech.

If you are working in 3D you will have the benefit of being able to blend between two shapes to create unique shapes that may match a particular sound.

Once you have designed your mouth shapes, you need to break down the sound frame by frame and transfer that information onto an exposure sheet. A number of software packages will now allow you to do this automatically with fairly good results, but for the best and most accurate results it is recommended that you break down the

It is surprising how expressive a simple design can be. Just by moving the eyebrows these two expressions are completely different.

Your character's eyes should remain focused on something at all times, otherwise they will appear unengaged.

Even a slight misalignment of the character's eyes can be confusing to the audience.

Very subtle emotions can be created by a simple movement of the eyebrows. This expression of "mildly impressed" has been created by raising one eyebrow.

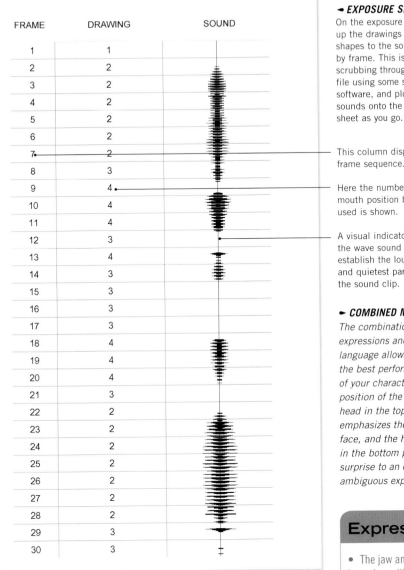

FRAME	DRAWING	SOUND
1	1	
2	2	
3	2	
4	2	
5	2	
6	2	
7	2	
8	3	
9	4	
10	4	
11	4	
12	3	
13	4	
14	3	
15	3	
16	3	
17	3	
18	4	
19	4	
20	4	
21	3	
22	2	
23	2	
24	2	
25	2	
26	2	
27	2	
28	2	
29	3	
30	3	

➤ **EXPOSURE SHEET**
On the exposure sheet, match up the drawings or mouth shapes to the sounds frame by frame. This is done by scrubbing through the sound file using some sound-editing software, and plotting the sounds onto the exposure sheet as you go.

This column displays the frame sequence.

Here the number of the mouth position being used is shown.

A visual indicator of the wave sound helps establish the loudest and quietest parts of the sound clip.

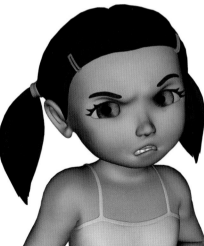

➤ **COMBINED MESSAGE**
The combination of facial expressions and body language allows you to get the best performance out of your characters. The position of the arms and head in the top pose emphasizes the anger of the face, and the hand gesture in the bottom pose suggests surprise to an otherwise ambiguous expression.

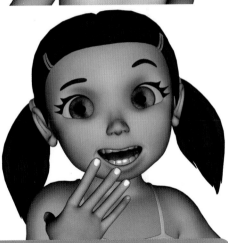

Expression tips

- The jaw and teeth are fixed to the skeletal structure of the head, and only the lower jaw will move. Don't have the upper jaw and teeth moving.
- To keep your lip-synch punchy and exciting, do not in-between every position.
- Make sure your character's eyes are focused on something. A vacant stare is off-putting.
- Use blinks when you change the direction of the eyes.
- The face is not exactly symmetrical, so always have one eye a little bit bigger than the other.

track manually, as you will have a better understanding of the sound to animate. Using a basic audio editing program, import the sound, ensuring the frame rate is set to the same as your animation (normally either 24, 25, or 30 fps). It is important that you listen to the sounds and not the words, and it is the phonetic sounds you will animate to. The vowel sounds A, E, I, O, and U are the main flow of speech, which can last several frames each and force the mouth to be open, whereas the consonants such as P, B, D, F, S, and T are harder and shorter sounds; these are the punctuation.

Basic mouth positions

There is no hard-and-fast rule about mouth positions, but the following eight shapes should cover most normal speech. Note that these shapes refer to the sounds of words, not necessarily the letters.

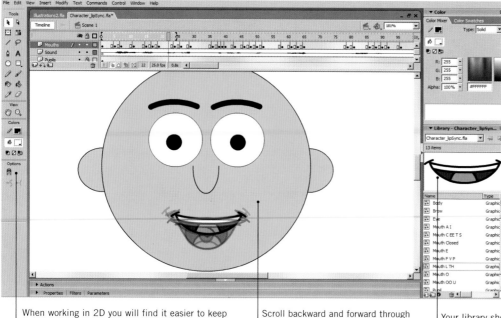

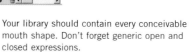

► ANIMATING LIP-SYNCH

When animating lip-synch it is not necessary to change the mouth position every frame. In fast speech, pick out the most dominant sounds and use those as your cues. Also ensure the top of the mouth remains more or less in the same place, as it is the bottom jaw that should move.

When working in 2D you will find it easier to keep onion skinning on to line up the mouths in position accurately.

Scroll backward and forward through the timeline and check your animation with the sound as you go.

Your library should contain every conceivable mouth shape. Don't forget generic open and closed expressions.

P B M

This is the closed mouth position used for silent gaps in the audio and the punchy sounds such as P, B, and M.

L TH D

This has the mouth slightly open and the tongue visibly touching the back of the top teeth. It is mainly used for L, but can work for TH and short D sounds too.

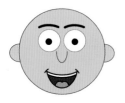

A I

This is for big vowel sounds such as A and I.

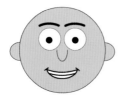

EE D C S T

This has the teeth closed together but with the lips open and is used for EE sounds such as a D, C, S, and T.

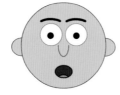

O

This is used for O sounds (as in "oh no").

U W OOO

This can be used for sounds that require more pursed lips such as U, W, and the OOO sound (as in "food").

F V

This is used for F and V sounds with the bottom lips tucked under the teeth.

E K N

This is used for smaller sounds such as E (as in "eh") and sometimes K or N if the speech is fast.

MAKING NOTES

Get into the habit of listening to sounds and not words and write down any notes phonetically; in other words record how they sound. The animation below of the character saying 'Hello, how are you today?' has been written phonetically.

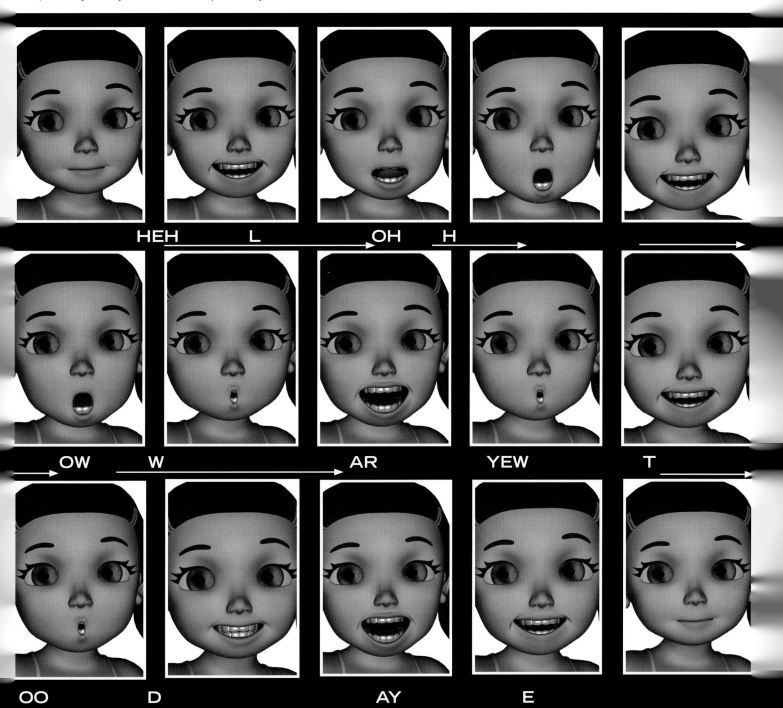

HEH　　L　　OH　　H

OW　　W　　AR　　YEW　　T

OO　　D　　AY　　E

CHAPTER 2
Production

See also: Motion theory page 64

Motion

An understanding of motion and dynamics is going to keep your animation looking exciting, punchy, and energetic.

Anatomy

A good appreciation of both human and animal anatomy is very important if you want to get the best out of your animation. An understanding of anatomy will help you grasp the dynamics of motion and allow you to move your characters correctly. Good drawing skills are obviously crucial for a 2D animator, but in order to get the best dynamics in their animation, good digital 3D animators will plan and sketch out their key positions on paper first. Keep a sketchbook and try to draw from observation every day. This will not only keep your drawing fresh, but may also trigger off new creative ideas for the future.

Silhouettes

A vital part of posing your characters to convey action is the ability to create strong silhouettes. The human eye will be drawn toward the silhouette outline of a striking pose and it makes reading the body language much clearer.

If you are working digitally it is easy to export your pose as a "matte" to create a black silhouette. If you can see what the character is doing from the silhouette then the pose will read well.

Line of action

To keep your animation as vibrant as possible, your poses should have not only a strong silhouette, but a dynamic line of action that passes through the body, accentuating the energy of the pose. This may seem like detail, but streamlining your postures adds aesthetic beauty to your animation and will in turn add appeal.

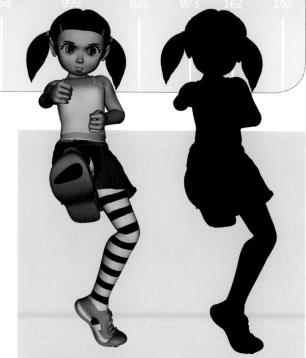

◊ AMBIGUOUS POSE
This pose viewed from the front does not have much impact. The silhouette is ambiguous.

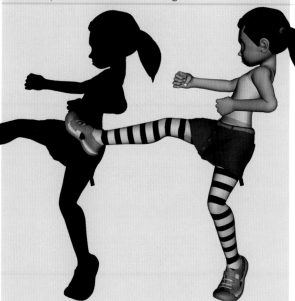

◊ BETTER POSITION
The same pose viewed from the side, however, is much more powerful and reads clearly. The position of the character in relation to the camera is as important as the pose.

Balance

One of the most disconcerting things about a character's stance can be when an animator has positioned it in an unnatural or unbalanced pose, making it look as if it is going to fall over at any second. If a person is holding a heavy bag, the body will naturally compensate by leaning slightly in the opposite direction to counterbalance the weight. Always look at where the center of gravity is on your character and adjust the pose accordingly to a natural equilibrium.

Tempo

Directly related to animation timing, tempo is the more subtle flow of action that runs through your animation sequence. Like a musician, a good animator will work a rhythm into their animation and the audience will literally be "carried along" by the tempo. This is not to imply that your whole sequence should animate to a regular beat, but it should flow seamlessly with apparent ease rather than staggering along with awkward stops and starts.

Weight

Weight as a principle of animation has already been discussed (see page 70) but that was talking about the weight of the character itself: A fat character will walk differently from a thin one, for example. However, external forces of weight can also affect a character's posture and animation. Deciding how your character will lift up a suitcase, and then convincing the audience that the suitcase is really heavy, so that the character strains to pull it along, is a great challenge for an animator.

➤ LINE OF ACTION
As well as a clear silhouette, a strong "line of action" will also add impact to your pose. This illustration shows a character about to throw a ball. The character is leaning back, creating a small line of action, but it is quite a weak and boring posture.

The second pose has much more impact, purely because of the tighter and stronger line of action.

➤ CENTER OF GRAVITY
Double-check the center of gravity of your character poses. The first pose is awkward because the balance is emphasized toward the front, suggesting she is going to fall forward.

A small adjustment, by leaning the character back and balancing the legs, soon restores the balance and equilibrium.

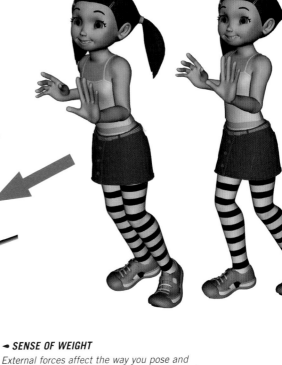

➤ SENSE OF WEIGHT
External forces affect the way you pose and balance your characters. A sense of weight is suggested by this posture, with a strong line of action arching up the body.

CHAPTER 2
Production

Walks

There is no generic way of walking, but the basic mechanics are always the same.

A walk is probably one of the hardest things to animate. It requires acute observation, and a good understanding of anatomy, performance, and mechanical control. In terms of performance, the way people walk reveals their character and mood, and from a physical point of view the weight, gender, and age make a difference to the walk. The number of different types of walks is infinite; however, from a mechanical perspective there are some fundamental basics to grasp.

If you analyze some Eadweard Muybridge sequences (see page 90), or perhaps some video footage that you have taken of a friend walking, you will notice that the whole body twists, leans, and stretches as it tries to balance itself with every step.

The best way to appreciate how a walk works is to stroll around the room yourself,

paying attention to what is going on with the various parts of your body. As you step forward you will feel your whole body moving forward, your arms will balance to stop you tipping sideways, and your leg will come forward, taking the entire weight of the body as it touches the ground. If the foot is not in the correct position, you will fall flat on your face. Your leg will straighten up and project your body forward, leaning in the direction of travel, at which point the other leg moves forward and takes the weight and the cycle starts again.

▾ WALK CYCLES

Rather than animate a character all the way across a screen, some animators animate a character "on the spot" as if it were walking on a treadmill, and then loop that cycle and pan the whole animation across the shot. If you do this, ensure that you make the incremental distance along the floor between each foot pose exactly the same. If you don't, your character will appear to "skate" across the ground.

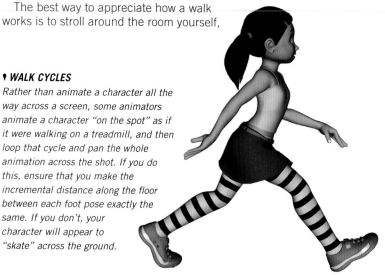

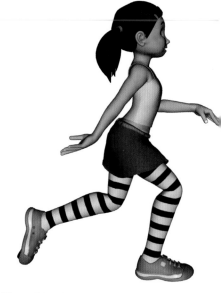

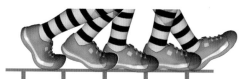

1 Let's start the walk from this extended position, with the body leaning forward and the weight about to transfer from the left leg to the right. At this point the legs are the farthest apart and the arms move in parallel with the opposite leg to give balance.

2 The weight of the body is now fully on the right leg, which bends to compensate and lowers the entire body to its lowest position in a walk. The body begins to twist to the left to balance, and the arms continue to swing out to their widest part. This position is known as the "recoil" position.

Assignment

Video yourself walking across the screen in a number of different "moods," and then analyze the footage to see what exactly is going on with the mechanics of the walk. Choose one walk and, using this as reference, animate a character walking in the same way.

Timing

How many frames a walk will take depends on mood, the weight of the person, and the type of walk. An average stroll will take about half a second (so about 12 frames at 25fps or 15 frames at 30fps) per step, in other words about one second per two-step cycle. Larger characters will have slower walks, while small characters walk much faster, although this will of course also depend on whether they are happy or sad.

Walking tips

• Don't forget secondary animation on wrists to make your arm swings more interesting.

• Twist the body from side to side.

• To keep it less confusing, start your walk with the two extreme extended positions as keys, and use the passing position as your breakdown pose.

• Practice all kinds of different walks to improve your timing and animation skills.

• Always do the walk you are trying to animate yourself so you can feel the movement in your own body.

→ WALK OF DESPAIR
A walk will reflect the mood of your character. A depressed character will probably shuffle with small, slow steps, with less upper body movement.

↑ HAPPY WALK
People often gesture as they walk, but will still use their upper body for balance. Happy walks have bigger, quicker strides, and probably more bounce than usual.

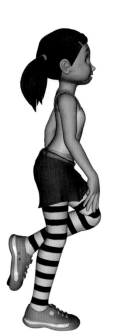

3 This is known as the "passing" position, where the supporting leg straightens while the opposite leg passes the center point. The body is leaning forward and the upper body is facing forward with no twist. The right arm swings forward to correspond with the left "passing" leg.

4 The left foot is now in freefall as the body is leaning forward and is the only thing that will keep it from falling. The upper body is twisting to the left as the right arm swings forward in an attempt to balance the rest of the body. The right (rear) leg is propelling the body forward as the weight begins to shift off it.

5 The left leg makes contact with the ground, and the step is complete. The second half of the cycle is an exact mirror of the first half; if not it may cause an unwanted limp.

See also: Stretch and squash page 68, Overlapping action page 72, Motion page 84

CHAPTER 2
Production

Technique and practice

Animation is all an illusion, and one of its best-kept secrets is cheating! You have already looked at some of the ways you can get the best out of your animation from a performance and physical point of view; here are some of the tricks of the trade to squeeze that extra bit of life out of your animation.

The great animator Norman McLaren once said that animation wasn't about the frames, but that it was what happened between the frames that was important. When we watch animation, what we are seeing is of course an optical illusion—a fast succession of sequential images—all slightly different—which give the impression of movement because our brains fill in the gaps. This, in scientific terms, is called the "persistence of vision."

Arcs
In one way or another, animation is all about arcs, whether in the positions of your movement, or in your graph editor. Straight lines are boring, mechanical, and very rarely occur in nature; most movement will look best if you animate in arcs of action. Animating movement through arcs will give your animation a much better sense of flow.

Line bending (the bendy ruler technique)
This is a little trick that works well with fast-moving objects and really does add snappiness to your animation. Imagine a flexible stick or cane being flicked. As the cane moves through the air, the air resistance will cause it to bend. This can be applied to animating solid objects, including things that don't really bend, such as arms.

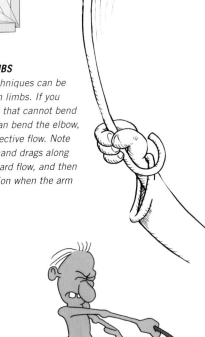

⬧ AVOID STRAIGHT LINES

1 If you had to animate a plank of wood falling from an upright position to the ground you might assume it would fall in a straight line.

2 The plank would fall along an arc until it hit the ground, and it would be logical to think that an in-between position would look something like this.

3 To give it a little bit of extra flow, put a bend on the plank, as shown here.

⬧ ANIMATING HUMAN LIMBS

Arcs and line-bending techniques can be used effectively on human limbs. If you have made a model in 3D that cannot bend its limbs, providing you can bend the elbow, you can still create an effective flow. Note in this example how the hand drags along the arc, resisting the forward flow, and then flops on the overlap position when the arm stops moving.

➨ TECHNIQUES IN PRACTICE

This animation sequence is a good example of arcs, line bending, distortion, and exaggeration. The fly swat bends as the character tries to catch an invisible fly, and on a number of frames the arms are bent too, to emphasize both the line of action and to add punch to the animation. The character is also distorted on several frames, which as held poses would not work, but as part of a fast-moving sequence adds energy and comedy.

Distortion and exaggeration

The best animators are normally very good at drawing; however, people who are excellent at drawing often make average animators. This is because as an animator you often have to create a pose that just looks wrong in isolation, but you know that once it is playing out at 25 or 30 frames per second, and in context with other poses, it will work. An illustrator will want to make every pose perfect as a single image, and that is a mistake. An animator will often put an extra bit of twist in a pose, stretch out a limb unnaturally, squash and stretch the character, and generally pull it around, distorting and exaggerating the figure. As long as this is not done on frames that are held, then it is perfectly acceptable.

Assignment

Design a very simple character and animate a sequence, in rough pencil on paper, of the character falling down some stairs. Think how you can pull, stretch, and distort the character around as it tumbles, considering the techniques covered on these pages.

CHAPTER 2
Production

See also: Motion page 84

Animation methods

All animators have their own working methods, but there are two principal approaches to consider.

Pose-to-pose

This is a very precise method of animation, often used by larger studios where the animator will "key out" the sequence with a series of key poses with assigned key frames. These frames may be several frames apart and the animator (or an assistant) then makes a second pass of the sequence, creating the breakdown and in-between positions. This method of animation allows the animator to hit certain poses at exactly the right point in the timeline.

Straight ahead

This method is a bit more difficult to control, and involves the animator animating the entire sequence from frame one to the end of the shot without using key poses. It can be very hit-and-miss, especially if there is a specific cue to hit midshot, but does often create very exciting and spontaneous animation.

If you decide to try this method, it is essential to have planned out the sequence meticulously with thumbnail sketches beforehand, or else the sequence will look unfocused and the action may wander and will probably be too long.

Many animators will use a combination of both methods, but most have a preference, depending on their own style of animation.

Breakdowns

These are the "in-between" poses that "break down" two keys in a sequence of animation, and you must not overlook the importance of these positions. Never, ever simply allow your software to in-between your poses, as your animation will look dull and mechanical, even with the best key poses ever. Computers in-between poses

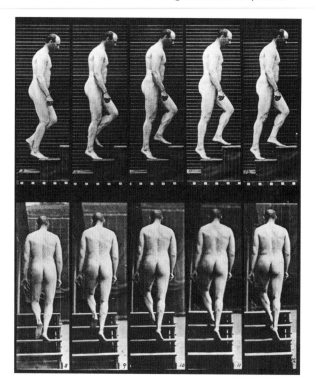

→ HISTORY

The 19th-century photographer Eadweard Muybridge made an extensive study of human and animal motion, and his work is still an essential reference source to animators. Originally motivated to settle an argument and prove that all four hooves of a horse do leave the ground simultaneously during a gallop, Muybridge set up multiple cameras to capture the movement not just of horses, but all kinds of animals and humans.

by taking the exact halfway point between every element of each pose, and then giving you a smooth transition (just to make sure it looks mechanical).

A breakdown pose will never be exactly halfway between two poses: It depends entirely on the speed and weight of the action, and the direction, the perspective, distortion, timing, and tempo of the animation. Computers will also not know how to cheat—they are far too logical to be good animators.

⬩ PERSPECTIVE
Perspective is a great device for keeping your animation looking dynamic, and engages the audience. This can be exaggerated by using wide-angle lenses in 3D or exaggerating the drawings in 2D.

PERSPECTIVE PROBLEMS IN DIGITAL 2D

If you are working in digital 2D, most software will only work in two dimensions, X and Y, and will not have a Z axis controlling the depth. The software will therefore have no understanding of depth and perspective...

Computer places in-between here.

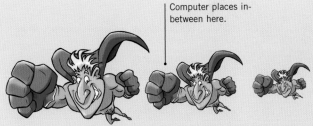

...the computer will therefore place the in-between position here, which is a logical halfway point using two-dimensional calculations, but incorrect if you want to make it look as if the superhero is flying toward us from a distance at a constant speed.

Correct position is here.

Because of perspective, the correct halfway position is actually here. If you imagine standing on a long straight road with equally spaced telegraph poles running along one side, from where you are standing they will appear to be getting closer to each other the further away they are from you, but of course it is perspective that gives that illusion.

POSITIONING THE BREAKDOWN I

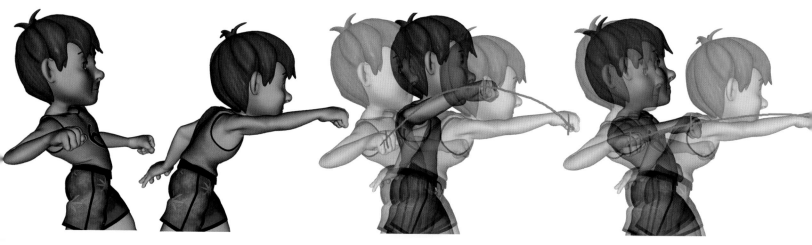

1 Take two key poses and think about where you would put the breakdown pose.

2 Here the breakdown pose has been generated by the computer. The spacing could have been adjusted in the graph editor; however, this would not have affected the path. You can see that the arc of the fist is quite steep.

3 For a more dynamic and powerful punch, the in-between pose would work best like this. The pose is nearer to the first position to allow for acceleration of the punch and the fist has been lowered to give a more direct line for the punch, with a more gentle arc.

SPACING BREAKDOWN IMAGES

Deciding where to place your breakdown or in-between pose is not always logical and requires a certain amount of skill and judgment. Relying on the computer to work out the position for you will result in mechanical and lifeless animation. Here are some tips illustrated in theory with yellow balls and practice with jumping frogs.

1 Imagine these two circles are your two key frames which you need to break down with an in-between position, which is demonstrated in practice by a jumping frog.

2 A computer by default will logically position your in-between position in the middle, exactly between the two positions.

 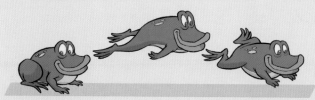

POSITIONING THE BREAKDOWN II

1 The breakdown position between these two key poses generated by the computer is logical, but incorrect...

2 That's more like it!

 Assignment

Give yourself a simple piece of animation to do, say for example a character picking up a ball and throwing it toward the camera (remember to use perspective). Animate it twice, once with the pose-to-pose method, and once straight ahead. Compare the results. Which sequence looks the most dynamic, and which one took longer?

3 However, you may want your animation to be accelerating, so your in-between pose would be closer to the first position. The frog's movement will appear much more natural if the movement is allowed to accelerate.

4 Or you may want your animation to be decelerating, in which case your in-between pose would be closer to the final position.

5 You may even want to have your action moving away from the camera and back again in perspective, in which case your breakdown position would be here. In all of these simple cases, there is no way for a computer to know what the context of your animation is, so it will choose the logical (and probably wrong) position.

94

Digital 3D artwork

Creating 3D artwork on a two-dimensional computer screen can be a challenge, but once mastered it opens a world of possibilities.

A digital 3D software package for animation is an entire virtual film studio in a box, and most animation professionals specialize in one aspect of the package (such as modeling or lighting), in just the same way that they would in a "real" film studio. The production process of a 3D production, up to the point of modeling, is identical to any other animation technique. In 3D software you can build puppets (models), create environments and props, animate them, light your shots, devise camera moves, and render your animation out as a finished movie.

There are a number of excellent 3D programs available, ranging from the more expensive professional industry packages such as Maya, 3ds Max, and Softimage XSI to free packages such as

Blender or DAZ Studio. The high-end packages offer learning editions that you can download for free (for a limited time period), so which one you go for is up to you, but research the various online forums and magazines to find out which one would be most suitable. If you are new to 3D, it is advisable to start with one of the less complex and more inexpensive packages such as DAZ Studio or Blender to familiarize yourself with the 3D working environment.

Modeling: the basics
If you know you will be creating some or all of your animation in 3D, it is worth keeping this in the back of your mind as you design your characters. Realistic hair and clothing, for example, will create additional work, and a complex character will slow you and your machine down as you animate. Keep it simple!

The final stage of designing a character for 3D would be to create a set of accurate drawings, or a maquette, that can be used as reference to begin building your model.

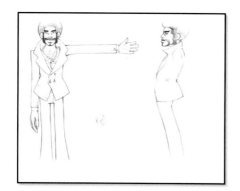

◀¶ IMAGE PLANES
Importing your final character model sheets (left) into your 3D program (below) will be useful reference as you sculpt and will keep your model in proportion and accurate to the original design. You will need a front-on and side view of the design, but it will help if you also have a three-quarter view. Don't forget to design details such as jewelry and make a separate large drawing for modeling reference.

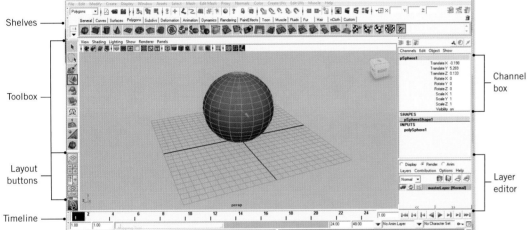

Curve

Point

Surface

FREE SOFTWARE
Free software programs such as DAZ Studio are good for learning the fundamentals of 3D animation, and the interface is laid out in a similar way to most 3D packages.

3D OBJECTS
A 3D model consists of a series of points joined together with curves, which create surfaces.

AUTODESK MAYA
Tools for manipulating 3D models (above) are arranged in "shelves" that can be customized.

Shelves

Toolbox

Layout buttons

Timeline

Channel box

Layer editor

Modeling in 3D is a specialized skill in its own right and modelers require an excellent eye as well as a good knowledge of volume, form, and anatomy. It is also a highly technical and precise process because models will need to be moved rigorously during animation, so they will have to withstand bends and twists naturally without looking peculiar.

Geometry
All 3D modeling is based on mathematical geometry, and although you do not need to understand the mathematics behind it, you will need to know how to manipulate geometry into shapes that can ultimately be animated and texture-mapped. Points, curves, and surfaces existing within the three-dimensional coordinates X, Y, and Z are what make up the essence of 3D modeling. You may begin with a primitive shape such as a cube or sphere, which you can manipulate to form a more specific shape, or you may start with points and lines that form surfaces that you can build up into a more complex shape.

CUSTOMIZING THE INTERFACE
As you get more familiar with your software you will want to customize your interface and use keyboard shortcuts that will really speed up your working progress. This interface has been set up to make the animation faster.

3D modeling tips

• Download a free trial or learning edition of one of the many 3D packages available and explore the interfaces to see which one you feel most comfortable with.

• Don't try to learn the whole package at once. These are complex programs, so take it bit by bit.

• Don't forget the importance of designing on paper before you start work on the computer. It will save you time in the long run.

• Keep it simple, especially if you are starting out. Simple characters are quicker to make, more fun to animate, and quite often more effective.

CHAPTER 2	Digital 3D artwork: geometry
Production	

Just as a sculptor might chip away at a large piece of wood or stone, a 3D modeler will chip away at a virtual shape.

Sculpting in 3D software has been likened to sculpting in stone. Most 3D programs provide you with a choice of primitive shapes with which to start your digital sculpting. You can push, pull, extend, and deform the shape until the final form begins to emerge.

Before you begin building your model you will need to decide which type of geometry to use. The two most common types, used by most 3D programs, are NURBS and polygon-based surfaces.

NURBS are four-sided shapes, the points of which are linked together with curves, and are generally used for more organic models. Polygons are shapes with three or more points that are joined together with straight lines and are generally used for nonorganic models such as walls or refrigerators.

You will then need to familiarize yourself with the way the program you are working with manipulates the shapes. Working with NURBS will involve changing the curves using control vertices (CVs) that modify the shape of the curves. Working with polygons will involve manipulating the points that are interconnected to form the shape. An individual point is called a vertex, and

these vertices can be pushed and pulled to adjust the shape, using various selection tools. A line joining two vertices is known as an edge, and where there are three or more vertices, a polygon, or face, is formed.

Basic tools that will extrude, bevel, and collapse your primitive shape's vertices, edges, and faces will "chip away" and extend your shape until it begins to resemble your design.

Geometry tips

- If you are new to modeling, don't start with anything too complex. 3D software takes time to learn and you will absorb more by setting yourself small tasks.

- Learn as many keyboard shortcuts as possible; this will speed up your modeling skills.

- Modelers need to be aware of what the model will be required to do in the animation. It may be required to twist, bend, and stretch, or it may be a static model. Always check before you begin building.

- Build your model in clay first. This will give you greater understanding of form and shape.

♦ PRIMITIVES
Most 3D programs provide you with a choice of primitive shapes to start your digital sculpting, normally a sphere, a cylinder, a cone, a torus (doughnut shape), a flat plane, and a cube (which can be stretched to a more rectangular shape).

Sphere

Cylinder

Cone

Torus

Flat plane

Cube

► **BASIC MODELING**

Using basic tools in 3D software you can intuitively start to construct shapes by manipulating the curves and vertices. Start with simple organic shapes until you become more confident with the software and the interface.

1 Create a basic primitive shape to start your model, in this case a sphere.

2 Using the appropriate selection tool you can grab a point and distort the surface.

3 Continue to pull the points and surfaces around until your design begins to take shape.

4 All packages allow you to view the object from different angles as you work and the shape is formed.

You can see that the greater the detail, the more surfaces and polygons there are, which in turn adds to the amount of data and the file size.

♦ **POLYGONS**

All models are constructed from complex surfaces, vertices, and edges manipulated and sculpted by the modeler. This model is constructed with straight-lined polygons.

📁 **Assignment**

Before you attempt anything too complex, build yourself a few abstract models using primitive shapes in NURBS and polygons, and figure out what effect the various manipulation tools have on the vertices.

▼ **NURBS OR POLYGONS?**

Deciding whether to use NURBS or polygons in your model depends on what it is you are trying to build. As a general rule, NURBS tend to work well for constructing organic shapes, whereas polygons are suited to nonorganic shapes.

This primitive torus shape was constructed using polygons, which have straight edges.

The same primitive, but made with NURBS. It has fewer surfaces because the edges are made up of curves.

Digital 3D artwork: rigging

Without a skeleton, you would not be able to move, and neither would a 3D model. To animate a model you will need to insert a skeleton so that it can be put into lots of interesting poses. This process is called rigging.

A character rig, like a skeleton, is made up of a number of "bones" and controls that the animator can manipulate and use to pose the character. The mechanics of the rig must be convincing and allow the character to bend and move in a believable manner. This is a complex task involving the fusion of bones, joints, deformers, surfaces, kinematics, and blendshapes. The bones will be assembled and joined together inside the mesh of your model.

In order for the computer to understand what order and priority it should give to certain parts of your rig it will ask you to create a hierarchy. The hierarchy is like a tree with a central root that spreads out to every moving part of the body. The root of a character is usually the pelvis, as this is where most body movement emanates from, and it is also more or less the center of gravity for a human.

The number of bones that you put into your rig depends on the level of detail and movement your character will be performing. You may, for example, decide to fully rig each hand so the fingers can bend and twist realistically, or you may simplify the bone structure so there are just one or two simple joints per finger.

❶ ➤ INSERTING THE RIG

Before a character can move, a rig or skeleton will need to be inserted into the body, with joints placed in strategic positions. Areas such as hands and feet can get very complex.

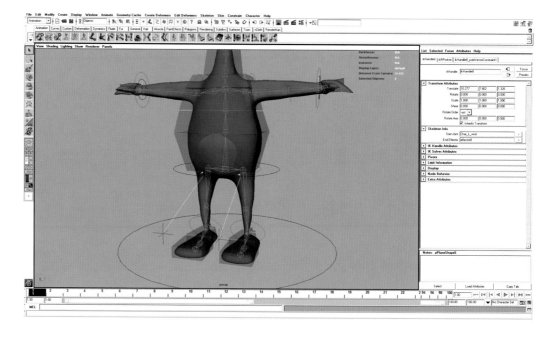

Once the bones of the rig have been joined together you will want to place certain restrictions on some of the movements, which may include rotation limits (such as preventing the neck from twisting 360 degrees) or parameters and joint limits to keep joints from bending in certain directions. The joints can then be manipulated, and providing the hierarchical structure is correct, movements can be controlled with kinematics, which can either be forward kinematics (FK) or inverse kinematics (IK). Forward kinematics is the most natural way to move the joints and works down the hierarchy, so if you want a character's hand to grab an object you would first rotate the shoulder, then the elbow, then the wrist. Inverse kinematics works up the hierarchy, so if you move the hand, the wrist, elbow, and shoulder would follow the movement of the hand. IK can be unpredictable, however, as the computer, being a logical beast, may decide to take the most direct route and bend the elbow the wrong way.

Facial rigging can be built and controlled through the use of bones and joints, but by far the best way to rig the face is to use a selection of shapes that can then be morphed from one to the other (rather like a stop-motion animator would use replacement heads). These shapes are called blendshapes, and are separately formed individual models that characterize a certain shape of the face. A blendshape editor can be created to mix the level of shapes to be blended and morphed through a slider control.

The final stage of rigging would be to make sure that once you start bending and twisting all the joints in your model, the surface shape mesh does not start to distort awkwardly. If you imagine a piece of paper rolled into a tube, and then you bend that rolled-up tube 90 degrees as if it were an arm, the point of bending in the middle would fold and crease. This is the shape a mesh of a 3D arm would make without any controlled mesh deformation. This process is also called "skinning," and what you aim to do is make the model look as if the mesh is the skin of a human, with muscle and bone beneath. Skinning is achieved by assigning all the vertices in the mesh a particular bone to follow, and around joints the vertices need to be weighted, as two bones may affect one vertex. Joints are where many of the unwanted distortions occur, and the most common way to smooth out joints is to use an envelope (like putting a Ping-Pong ball in the center of a tube) that will keep the joint from collapsing as it bends.

Once the model is fully rigged and skinned, it is crucial to fully test it to iron out any annoying bugs.

♦ HIERARCHY

The rig works just like a skeleton and is built with a hierarchy structure. Here you can see how the top of the hierarchy is the main bone near the shoulder (the humerus) and the fingers are the bottom.

The hierarchical structure of the whole model is displayed as a network

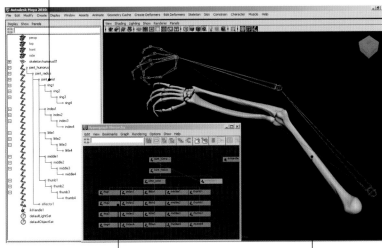

For checking the hierarchy and links the structure can also be viewed as a graph.

This model of a skeleton has a rig that looks very similar to the model itself.

◄ BLENDSHAPES

Here are the blendshapes created for one of the characters from Cockney Coppers *by Nick Mackie. When animating lip-synch, rather than creating a new mouth shape for every sound, the animator can use a preconstructed shape and simply replace the whole head shape on a particular frame on the timeline. These shapes can also be blended together to create halfway positions, hence the name "blendshapes."*

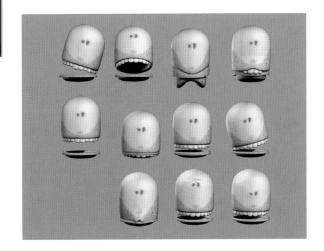

Digital 3D artwork: shading

The default look of most 3D models is flat, gray, and plastic. The final stage of modeling is to apply colors, shades, and textures.

To continue the analogy of digital modeling as sculpting, a finished model will be like a well-formed, smooth piece of clay with no detail, reflection, colors, or textures. The final job to be done to finish a model for production would be to define how the model's surface will look.

3D software needs to be told what the material qualities of every surface on the model are, and this work is normally split into two parts: shading and texturing.

Shading

Shading has a number of different attributes that need to be assigned to the surface of the model dealing with the actual substance of the material. Basic shading gives the model a lifelike form by showing how the surface looks when light illuminates it. For example, a sphere looks three-dimensional because of the way light falls onto its surface, casting a shadow. If it were a uniform color with no shade, it would appear two-dimensional. The software also needs to know whether the material has any transparency, like a glass (which may cause light to refract), and also how shiny the material is. The glossier the object, the more it will reflect light, causing highlights, and possibly, if really shiny, reflecting the surrounding objects. Finally, as the default surface is extremely smooth, you will need to apply bumps or grains to the surface to give the model a little bit of texture, especially if the material is organic, such as wood. These surface reliefs are called bump and displacement maps.

Texturing

In addition to the surface relief of your model, you can add more detail by mapping image textures onto the geometry of the surfaces. These texture maps can be procedural textures generated in 2D or 3D as mathematical attributes within the program or as file textures imported from any bitmap image, such as a photograph or artwork, that you have painted digitally. Photographic textures can be tiled across a surface, and providing there are no obvious edges to the texture, will look seamless, disguising the fact that it is a repeated pattern. This technique is often used for large surfaces such as walls and floors.

To paint the model using a program like Painter or Photoshop you will first need to create UV texture coordinates, which are used to assign textures to polygons. UV texture coordinates are mapped onto a 2D plane, which can then be exported into a 2D paint program to be painted, and then imported back into the 3D program to be wrapped around the model. There are also programs available such as ZBrush that allow you to paint directly onto the 3D model.

If you have a scene where a photograph or picture needs to be in the shot, or perhaps you have an object that requires a label, it is possible to import bitmap images and use texture placement. These placements can be mapped to the model's UV coordinates or projected onto the surface as a stencil map.

▶ SHADOW AND REFLECTION
A computer needs to be told where the light source is coming from and what material your model is made of so it can calculate the correct amount of shade and reflection.

▶ CREATING TEXTURE
Having established the type of reflective surface and shading your object requires, you will need to apply some sort of texture to the model. All objects in reality have some kind of texture, whether it be woodgrain, cloth, or skin.

This sphere has no shading or surface properties given to it and looks flat.

A simple light source starts to give the sphere a three-dimensional form.

By applying a transparency to the surface you can create a glass marble effect.

The surface of this sphere has been given some shine and highlights.

Surfaces can also be made to reflect objects nearby. This sphere has a reflective shine.

The surface here has been given a bump map, which applies raised bumps and grains.

This sphere has a photographic texture applied to it, which repeats all over the object.

A photographic texture of any size can be wrapped around the object or area of the object.

Any artwork, as long as it is a bitmap, can be used as a texture for mapping onto the model.

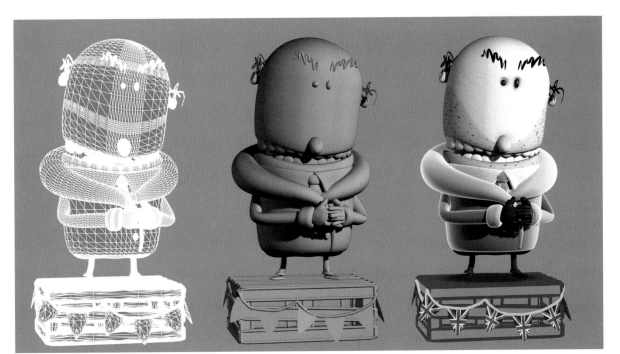

➤ MODEL STAGES

Three stages of modeling are shown here. The first image, on the left, shows the model in its basic geometric form made up of hundreds of polygon surfaces. The central image is what the model looks like finished but before it has had any work done on the surfaces, and finally the image on the right shows the model with the lighting, shading, and texturing all finished.

See also: Staging page 62, Types of shot page 106

Scene planning

If you fail to plan—you plan to fail. Working from the storyboard, the job of a scene planner is to compile all the elements of a shot into a composition that not only looks good but also helps tell the story, and gives the animator space to perform the action.

The basic story and shot structure will have been decided and designed at the storyboard stage, but the main function of scene planning is to put detail into the shots, making sure that continuity works from shot to shot, planning any camera moves, ensuring the length and action of each shot is clear, and creating a library of backgrounds and assets that can be used and re-used throughout the production.

Before planning a shot you first need to make sure you are aware of the story as a whole and know what stage of the story you are at: How will the scene move the story forward, and what is the motivation of the characters in that shot? You will then need to look at how your scene hooks up to shots before and after it, and also at whether the scene needs to reveal any important story plot points either to the character or to the audience. You can then begin to prepare the shot for specific details of the action by writing notes and instructions for the animation. The character must not be asked to perform any actions that are "out of character" or do not contribute in any way to the story, and if a character does move, you should always give clear motivational acting directions. Never add a gag or dramatic action

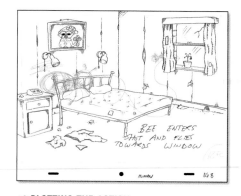

◆▼ PLOTTING THE ACTION
A 3D scene plan will compose the shot elements and set up the camera position. At this stage everything is kept at low resolution for speed, so any textures and shading are kept to an absolute minimum. The scene planner will usually block out any essential positions the characters or cameras need to be in along the timeline.

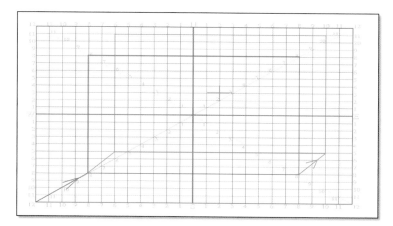

◆ FIELD CHART
A graticule or field chart is used to plot camera moves, and gives the scene planner a way to measure the size of the camera view.

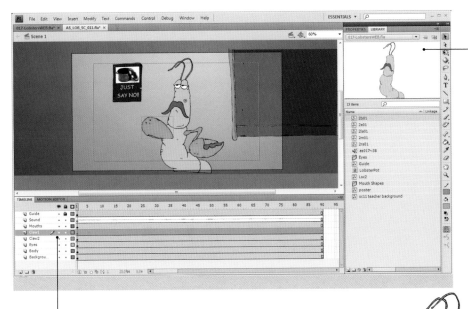

This 2D scene in Flash is made up of pre-drawn elements that the scene planner brings into the scene library.

All the elements are put into the correct position in their separate layers ready for animating.

Scene planning tips

- Use a camera move only if it is essential to the storytelling or action of the scene.

- Every character movement should have a motivational reason, and this should be clear in the scene plan.

- Scene planning files can be rendered out in low resolution and assembled in a rough edit. These are known as block-throughs, or blocking the animation.

- Clarity is the key to a good scene plan. Leave nothing to chance.

- Always keep the style of the shots consistent. A sudden dramatic low camera angle will disrupt the flow if all your other shots are shot from eye level.

→ ELEMENTS

Working in digital 2D or 3D, each scene will need to be planned. The planning involves bringing in all the elements required for a shot. The scene planner will put the character into a typical pose required for the scene, and check to ensure all the correct eyes and mouths have been designed.

that is not in the script or storyboard without checking with the director, as it may spoil the buildup to a bigger gag, or disrupt the flow of the story.

Compose the shot so it is the most appropriate design for the scene, leading the audience's focus to where you need them to be looking, and staging the shot by selecting the most suitable camera angle. Put your characters in positions and poses that are clear with a sense of space for the animation to work in.

Finally you need to become the cinematographer, double-checking that there are no obvious continuity errors. Work on getting the most effective perspective with the use of camera angles, type of shot, camera focal length, and whether you need to use any specific camera moves. Using the timeline, you may want to key out any important poses or positions of characters.

A scene planner is a relatively new job in a digital animation studio, and it is slightly different from the traditional role of a layout artist. A layout artist will design each shot, normally in 2D, or in simple blocks in 3D before the elements are fully designed and built, providing a detailed blueprint for the production. Scene planning normally involves the arranging and composition of 2D or 3D digital elements that are finished into a digital scene file that can then be passed to other members of the production crew.

→ PROPS

Planning a scene in 3D is similar to 2D, placing all the elements into position ready for the animation. Any missing props need to be made at this stage, otherwise it will hold up the animation.

Scene planning: camera

In digital animation the camera is often not treated with the respect it deserves. Of course, digital animation is not an actual lens-based medium, but remember that you are replicating one. So a good knowledge and understanding of motion-picture cameras and lenses is important in scene planning.

Camera moves

Camera moves are part of the scene-planning process and should be choreographed carefully. One of the benefits of digital animation software is that you can easily move camera positions, but this has an annoying downside: Novice animators will move cameras aimlessly for no reason, to the great detriment of the production.

Camera moves should always be for a specific reason; a track-in focuses the audience's attention on a particular area, whereas a track-out is often used to reveal something to the audience. A pan can be used as a reveal, or to follow a piece of action.

Never, ever use a camera move unless you have a good reason; it is far better to have the action moving through the shot. If you do decide to have a camera move, don't put a camera movement in the following shot too—especially if it is going in the reverse direction—otherwise you will cause a disturbing effect called yo-yoing, which will just make your audience feel nauseated.

The only exceptions, where lots of camera moves are acceptable, are particularly well-choreographed action sequences (although if you actually study most film action sequences you will see very few camera moves), or if you are making a music video where the Dutch angles and camera moves are part of that genre.

Focal length

Film cameras use lenses that have a variety of different focal lengths, similar to those used in photography, and when planning a shot you may decide to replicate the effect of a particular type of lens. A wide-angle lens (20 mm or less) will have a wide field of vision, allowing you to incorporate more into your image—but it will exaggerate the depth. A standard lens (35 mm) roughly equates to the human eye's field of vision, while a telephoto lens (80 mm or more) will narrow your field of vision, focusing on distant objects, but will also have the effect of flattening the image.

Depth of field

Another useful tool for scene planning and directing the audience's view is to use focus and depth of field. The depth of field refers to the distance between two points in a shot that are in focus; anything not within the depth of field will appear out of focus. Wide-angle lenses generally have a large depth of field and

♥ DEPTH OF FIELD
A small depth of field, shown in the left-hand two images, isolates either the fence in the foreground, or the cat. A wider depth of field (right) gives you the opportunity to focus on both the foreground and background at the same time.

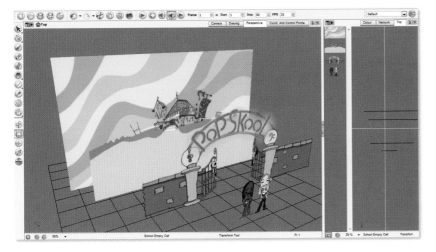

REPLICATING MULTIPLANE
Even in 2D it is possible to create an illusion of depth by using multiplane camera techniques.

FOCAL LENGTH
The focal length of a lens affects the field of vision. The background in the top image, taken with a wide-angle lens, incorporates more, while the bottom image, taken with a telephoto lens, has a much narrower field of vision, and looks a little bit flatter.

practically everything in the shot will be in focus, whereas a telephoto lens will have a very small depth of field, with objects behind and in front of the main subject out of focus.

One of the most effective shots in cinematography is the "pull focus" shot, where the focus will change from an object in the foreground to one in the distance. This shot can be achieved only with a small depth of field.

All these effects can be achieved digitally by careful planning of the scene and an understanding of the camera functions available in the program you are using. Some animation programs such as Flash do not have a camera function, but camera effects can be imitated by moving and scaling the artwork.

Multiplane camera
Working in 3D, you will be used to working in the Z axis, the coordinate that controls depth. However, in 2D animation, all movements use just X or Y— though it is entirely possible to create very convincing three-dimensional scenes by using a multiplane camera. The purpose of a multiplane camera is to have layers of animation, and with clever design and scene planning, the illusion of depth will be created as you move the camera through the layers, with each one moving separately.

The exposure sheet
When scene planning, all your scene directions and camera moves need to be noted, and the best place to do that is on an exposure sheet, which maps out the shot frame by frame, allowing you to be frame-accurate with your instructions. An exposure sheet is essentially a timeline that reads vertically instead of horizontally. Every member of an animation crew should be familiar with reading an exposure sheet.

SETTING UP YOUR CAMERA IN 3D
Learn and apply basic photographic principles such as types of lenses, camera angles, and depth of field.

MULTIPLANE TECHNIQUES
In this illustration an illusion of depth will be created by the camera focusing on the center layer, B, while the background, C, and the foreground, A, will be blurred. With digital software, it is now possible to replicate this multiplane technique, layering an unlimited number of 2D and 3D artwork elements.

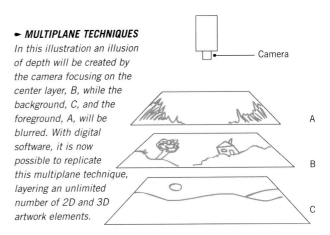

EXPOSURE SHEET
The exposure sheet is where all the information for a scene plan can be kept. This includes the camera field sizes and moves, the elements of the scene, and any animation cues.

See also: The storyboard page 24, Editing animation: theory page 128

Types of shot

Knowing what type of shot to use, and when and where, is an important part of the craft of filmmaking and animation.

There is a convention of labeling certain types of camera shots according to how far the camera is away from the subject, its angle, and whether it is moving. These labels are used to describe shots all the way through the production process, starting with the initial rough storyboards (see page 24) all the way through to shot design and the final compositing, so it is important that every member of the crew has an understanding of what they are.

Different shots are not only used to keep the film looking visually fresh, they also have emotional connotations and can help add to the story. For example, long shots are normally used to place the story into a certain location, and are often used at the beginning of scenes to establish where you are for the rest of the scene. These conventions of film grammar are understood and, to a certain extent, expected by the audience. If you decide to break with convention (which of course you are perfectly entitled to do!), be aware that you may confuse the audience.

Camera angles are a useful tool for adding drama and can be used to great effect. An eye-level shot will look familiar and comfortable to an audience, but if you move your camera toward the floor and look up at the subject you will suggest power; likewise looking down on a subject will imply weakness and vulnerability. Camera movements are also a useful and effective device, but should be used only to help with the story, and not for their own sake.

When you come to edit your film, one of the general aesthetics to aim for is a good mix of different types of shots to keep the film looking varied and fresh. One of the biggest criticisms leveled at novice filmmakers is that they do not employ enough variety of shots and as a result their films look flat.

TWO SHOT
A two shot is when there are two characters in the shot. You can also have a "one shot" and a "three shot."

OSS (OVER-SHOULDER SHOT)
A common shot used in conversation sequences, where you see one character over the shoulder of the other.

UP SHOT
If you want your character to look powerful and imposing you can do so by moving your camera to a low position so it looks up at the subject. An extreme version of this is called a worm's-eye-view shot, when the camera is pointing directly into the sky.

DOWN SHOT
The camera can be used to make your character look insecure or vulnerable by having it look down on the character. An extreme version of this is called a bird's-eye-view shot where the camera looks directly at the ground from above.

DUTCH ANGLE
This is when the camera is at an unusual or tilted angle, often used for fast-paced action sequences or music videos.

XLS (EXTREME LONG SHOT)
This shot is often used as an establishing shot, either at the beginning of a scene or a film. These shots are normally of landscapes or cityscapes.

LS (LONG SHOT)
A long shot can be used as an establishing shot, but is normally close enough to be able to recognize characters and their general postures, although not their facial expressions. It shows where they are within the location.

CU (CLOSE-UP)
If you want a character to show a reaction or other facial expression, then you would choose a close-up. There would normally be room for only one character in a close-up.

⏴⏵ KNOW YOUR CAMERA SHOTS

The types of shot, whether you are working in live action cinematography, or animation are the same. The three examples shown above of an extreme long shot, a long shot, and a close up are typical shots a cinematographer would use. Other commonly used shots are shown opposite and below. Occasionally you may want to use a variation of one of these main types of shot such as XCU (extreme close up), which will typically show a very small detail such as an eye filling the entire screen.

Camera moves

Pan
A panning shot is a horizontal movement to the left or right, but the camera would be fixed to a tripod and revolve.

Tilt
This is a shot that moves vertically up or down, with the camera tilting on a fixed tripod.

Pedestal
A pedestal shot is also a movement vertically, however the platform the camera is fixed on will move up and down, not the camera.

Crane
In live action these shots are expensive, as the camera needs to be mounted on a crane or cherry picker. A typical crane shot would start on a medium shot of a character and then track out and move up and out until a whole street from above was in view.

Handheld
If you want your film to have a documentary feel, you can re-create a handheld effect by simulating handheld movement.

TRACK (OR TRUCK)
A track in or out is when the camera moves closer to or farther away from the subject. This is subtly different from a zoom, which in live action refers to the camera remaining fixed but the lens zooming in or out on the subject by adjusting the focal length. Tracks and zooms, although they do more or less the same thing, have a slightly different effect.

DOLLY
This is also a tracking shot, but usually refers to a movement left or right. In live action the camera would be mounted on tracks or dolly wheels.

Continuity

To avoid bad continuity you should think in sequences, not individual shots.

An animated film is normally made up of a sequence of shots and these shots should present a continuous, coherent, and logical flow, accompanied by sound. It is the flow of the story and action that dictates the success or failure of your production.

A film that has bad continuity is frustrating to watch because the flow is constantly being disrupted, but in animation this can be very easily avoided by good planning and a detailed storyboard.

Without continuity a film will be a jumble of random shots, and while these shots may have interesting movement and action they are not a series of flowing images. Continuity invites the audience to be actively engaged in the story without frustrating distractions. If the audience has to try to figure out what is supposed to be going on in the story at any point, you as a film-maker have lost them.

Continuity can be controlled by being aware of the six key areas where errors can occur: space, time, direction, costume, hookups, and sound.

Space
It is very easy to disorient your audience by having your characters apparently moving from one part of the set to another from shot to shot. Try to keep all your characters and cameras in logical positions, and choreograph the characters around the set as if you are directing a stage performance, keeping the cameras facing toward the "stage."

For example, if you open a scene with a shot of a remote farmhouse, you assume that the following interior shots are inside that farmhouse.

You must choreograph your characters to be consistent in their positions within that scene. If a

⬥ COMPRESSED TIME
*This sequence in screen time would last only 20 seconds or so, but because of the way it is structured will read longer. **Frame 1**, the establishing shot, sets the scene on board a ship. When we cut to **frame 2** we know the character, the man in the hat, is on board, and the use of the flowers as a prop suggests he is searching for a loved one. **Frames 3–7** stretch out time by showing an increasing number of secondary characters, often lovers, having a good time as he walks through the busy deck, emphasizing his increasing solitude. By **frame 8** we start to empathize with the man in the hat, who by now is starting to show signs of emotion, and we wonder whether whoever he is looking for is ever going to materialize.*

character turns to their left to walk toward a door, you expect the following shot, which, say, is a close-up of the door handle, to have the hand entering the shot from the left and grabbing the handle.

Time

You must keep your audience engaged by making sure the continuity of time is coherent and believable. If a character in an apartment exits screen left and then you cut to an exterior of a high-rise building and the same character exits the building through a door, the viewer does not question how long it has taken that character to walk down the stairs or get the elevator. In our heads we compress that time and we just accept it. If, however, we have the same shot of the character exiting shot left and then cut to a shot of the door inside the apartment and the character enters the shot too quickly, the flow will appear disjointed.

Direction

The flow and direction of characters in a sequence of shots should be consistent from shot to shot. If you are putting together a sequence of shots to show a journey, the screen direction of the character should always be going the same way. The moment the character moves in the opposite direction, it will appear as if they have turned back.

Hookups

These should be established at the scene-planning stage, but always make sure the shot you are animating will hook up with the previous and following shots. This includes watching out for expressions on faces, that any movement that begins toward the end of one shot continues at the beginning of the next, and primarily, the positions of the characters. If a character is sitting in one shot, don't have them suddenly standing in the next.

Crossing the line

One of the most common and disorienting continuity errors, especially in 3D animation, is called "crossing the line," where characters suddenly appear to be facing the wrong direction. The best way to picture the effect is to imagine a football match where all the cameras are lined up to film the action on one side of the pitch, except for one. Every time the director cuts to that one camera, all the action would suddenly appear to be going the wrong way, and totally disorient the audience.

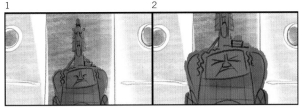

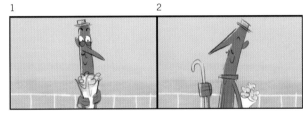

▲ DIRECTION
Frames 1–3 are the man in the hat's POV (point of view) showing other people coming through a door. Notice that the tall character walks off screen right in **frame 3**. We cut to **frame 4** to focus on the man in the hat. Because the camera is now facing the opposite way, the same tall character walks in from screen right in **frame 5**, but we accept this as part of the tall character's flow and direction.

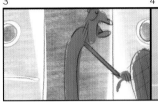

▲ COSTUME
A simple but common mistake is for props to suddenly appear. **Frame 1** *clearly shows the man in the hat holding the flowers with both hands, and suddenly in* **frame 2** *he has a cane. These inconsistencies should be corrected at the storyboard stage.*

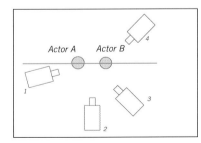

FACING THE WRONG WAY
The illustration here shows two actors (A and B) with four cameras pointing at them. Cameras 1 to 3 will show Actor A on the left. If you cut to a shot from camera 4, which is across the red line, Actor A would suddenly appear on the right and your sequence will not make sense.

Continuity tips

- When storyboarding a scene, draw yourself an overhead map of the scene, plotting the position of the characters and cameras. This will keep your space continuity in check.

- Always find out what is happening in the shots before and after the shot you are about to animate, so you can make sure your shot will hook up.

- Don't leave anything to chance. Thoroughly plan your shots in pre-production. By the time you get to animating you will be wanting to concentrate on the individual shot and may overlook a basic continuity error.

Rendering and output

The process of outputting an animation from 3D software involves some serious computer power.

Depending on the final medium and the post-production technique of your project, your shots need to be rendered out frame by frame to the highest quality possible. In 3D this means the computer has to make millions of mathematical calculations in relation to the surfaces, geometry, and textures for each single frame, and as the production may have thousands of separate frames, rendering will certainly put your computer to the test.

Even though computer processing power is improving all the time, software developers continually build more and more complex versions of their programs, so render times remain long.

The more computers you have, the faster your rendering times will be, and animation studios normally have clusters of machines totally dedicated to rendering. These "render farms" work around the clock, processing millions of calculations and creating high-resolution images. Even with banks of high-spec machines, one frame can still take several hours to render if it is a particularly complex image.

When preparing your software for rendering it will ask you what pixel resolution you want. NTSC (the television system used in North America) has a different pixel ratio size to PAL (the television system used in Europe) and, with television stations now broadcasting in wide-screen and high definition, you should be careful to check which size you need. The table below gives some of the square pixel aspect ratios sizes for comparison, but if in doubt consult a video engineer or technician.

Next, you will be asked the file format. Although most programs give you the option to export movie files such as Quicktimes or AVIs, for the best quality (and for backup purposes) it is always advisable to export a sequence of images such as TIFF or TGA files. These will be uncompressed and can very easily be imported into an editing program such as Premiere or Final Cut. As a rule you should render movie files only for tests, not final renders.

Most artists will render out their shots in multiple layers called passes, which will later be combined together again and finished in the final composite. This process has a number of advantages, and while it may take a little longer to render, you will have complete control over each layer and have greater creative possibilities in the long run.

❢ PIXEL ASPECT RATIOS
There is an ever-increasing number of different formats and confusing aspect ratios. Be warned!

Pixel aspect ratios

NTSC SD 4:3	720 x 480
NTSC SD 16:9 (WIDESCREEN)	853 x 480
PAL SD 4:3	720 x 576
PAL 16:9 (WIDESCREEN)	1024 x 576
1080 HD	1920 x 1080
IPOD	320 x 240

◆ RENDER SETUP

Most software will allow you to output your animation as movie files or as image sequences. For optimum quality, output as an image sequence, as this will be uncompressed at the pixel resolution required. Batch-render several sequences held in a queue when you are away from the machine, ideally overnight.

You can render out the whole animation, or separate elements, depending on how much control you want in compositing.

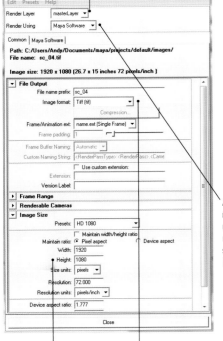

All software has a built-in render application, but you may decide to purchase more powerful rendering software such as Pixar's Renderman.

Always output your master renders as image sequences.

Most software will give you industry-standard presets for the image size and aspect ratio. There are many different formats, so get advice on what final format you need for your final distribution media.

Rendering tips

• Buy another computer to do your rendering rather than slowing down your work machine. Rendering really does take over all your machine's power, and you will not be able to have it working in the background.

• If possible, you should render out separate layers of your shot, which can then be composited back together and tweaked.

• Do as many render tests as possible. You need to make sure that the render gives your animation the best range of color and contrast possible.

◆ RENDER PASSES

To enable you to adjust the color and apply effects to your characters, you can render out your animation in separate passes with mattes for final compositing. Mattes are basically frames with holes that mask out everything apart from the area where you want to apply an effect.

See also: Concept design page 34, Staging page 62

CHAPTER 2
Production

Lighting

Light affects the way we see the world and sets the mood and atmosphere. Art directors use lighting to create mood and drama to support the emotional context of a scene.

In the real world, light starts from a source such as the sun or a lamp and is either bounced or absorbed by surfaces, creating a complex mix of shadows, colors, and highlights that make up what you see.

In digital animation you need to understand light behavior in order to create the desired effect and mood in your lighting. Although lighting effects can be added at a later stage, two-dimensional animation will have the lighting designed into the artwork. 3D animation allows you to light the environment and characters as if they were on a real film set.

The most common and basic lighting setup used by a DOP (director of photography) is three-point lighting, which simulates natural light, and consists of a key light, a fill light, and a backlight.

The key light is the primary source of light and is normally positioned above, in front, and to the side of the main subject. The fill light is a fairly diffused and soft light that fills in the shadows left by the rather harder key light, and is placed on the opposite side of the key light, often around camera height. If the fill light is too intense, it will make the subject look flat with little or no contrast. The backlight is used to the rear of the subject and has the effect of separating the character from the background. A background light may also be required to illuminate the background. (This is the fourth light in the four-point lighting setup.)

Simply by using a basic three- or four-point lighting setup, you should be able to achieve a number of different atmospheric moods suitable for whatever the mood of your shot requires. Adding other lights such as spotlights, floodlights, or filters such as colors and patterns will allow you to get quite advanced in your lighting.

There are many types of other specialty lights you may come

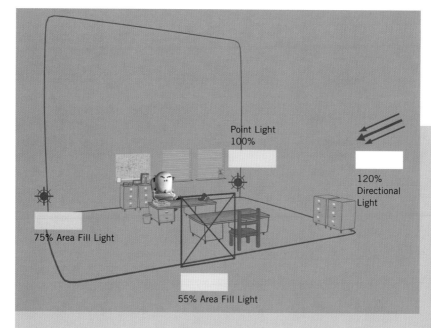

Point Light
100%

120%
Directional
Light

75% Area Fill Light

55% Area Fill Light

across besides the principal ones mentioned here. These include the spotlight, which will highlight a very small area quite intensely; the point light, which refers to a light within a shot, for example a lightbulb; or a floodlight, which fills the entire scene with a bright but flat light.

Hotspots

A hotspot will be created on an object if you have the lighting on it too bright, too intense, or too close. Hotspots burn out any colors or textures in the shot to white and spoil the scene, and unfortunately cannot be easily fixed without re-rendering or re-shooting.

Color temperature

Film lights have a variable intensity but they also have a temperature that can affect the overall color balance of your image. Color temperature is measured in Kelvin and ranges from about 1700K for a warm orange candlelight, to about 8000K for cold blue daylight. Because most animation is now color-balanced digitally, you are able to adjust the color balance of your shots with relative ease.

Assignment

Draw some basic primitive shapes such as a cube or a sphere in a loose medium such as charcoal or pastels, and experiment with how light from a three-point setup affects the shapes. This exercise can then be repeated in 3D and you can render out the results to compare them. Once you are feeling confident, design an interior room, and light the room for a midday shot and then again for dusk.

Three-point lighting

The most commonly used lighting is called three-point lighting, which is the basis for most lighting setups. **1 Key light**—creates too much contrast for regular use and the background remains dark; **2 Fill light**—used to soften the contrast, and to softly light the areas in shadow from the harsh key light; **3 Backlight**—lights the background softly and makes the foreground subject stand out; **4 Key, back, and fill lights combined.**

1

2

3

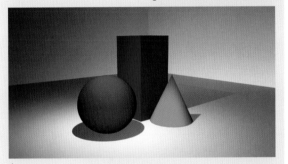
4

→ THREE-POINT SETUP
The three-point lighting setup in this shot from Cockney Coppers *shows the strong directional light coming from top right, which gives the character shape and form, and the diffused fill light placed near the camera, which takes away harsh shadows. The backlighting is created by two point lights, which simulate light coming in through the windows and help the character stand out from the background.*

→ FINAL RENDER
The final render of the shot shows the look of a three-point lighting setup, with the texture placed in the background.

CHAPTER 2
Production

Shot design

Good composition makes a shot appealing by drawing the audience in and keeping their attention.

Composition

The elements of your shot such as characters, props, and backgrounds must be arranged in a balanced and harmonious composition that is aesthetically pleasing to the audience. A bad composition not only looks lazy, it also disrupts the flow of a film. With digital animation it is very easy to adjust your shot elements and camera with a few simple clicks, so there is no excuse for bad composition. The audience's attention should always be directed toward the principal character or object, or a movement that is significant in telling the story, and this is achieved by arranging your elements thoughtfully.

As in most sections of this book, there are theories and rules to help you, but providing you understand the rules, they are always there to be broken!

Lines, shapes, and balance

As you are dealing with a moving medium, there are many tricks you can learn from film language when it

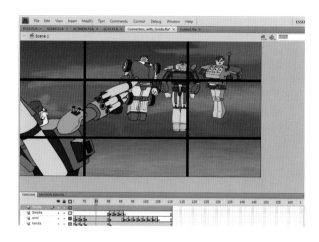

⬩ USING A GRID
Some digital animation software will have built-in guide views that will assist you in shot composition. If not, make yourself a grid template divided into thirds, and use that on a temporary layer.

⬩ RULE OF THIRDS
One of the best-known principles of visual composition is the rule of thirds, which effectively splits up a composition into nine equal sections, with a "power point" on each intersection. These intersections are where the eyes are naturally drawn to, so the most interesting and important elements of your shot should be placed on or around these points.

⬩ USING THE RULE OF THIRDS
In this frame notice how the composition uses the rule of thirds. The character's eyes are just below the top right power point, and she is pointing a zapper directly at the lower left power point. While the action takes place in the center horizontal third, the foreground sits comfortably in the lower third and the character occupies the right vertical third, the classic L-shape composition.

Assignment

A good way to build up your compositional skills is to take photographs. Using a digital camera, spend a day in your local area taking as many photographs as possible. You can use anything as your subject, but concentrate on framing the photographs using some of the rules of composition covered here. Load the photos into a computer and go through each one, analyzing the compositional merits.

comes to composing a shot. Lines are an important aspect of composition and can be very useful in guiding the audience's attention to a particular point of focus. Lines can be represented in a composition literally, for example a road, or by using trees, people, props, or buildings composed in straight or curved lines. These "imaginary" lines can be particularly effective where the audience "fills in the gaps" between objects. Lines should not split the frame into equal parts vertically, horizontally, or diagonally.

Shapes are a useful device in composition, and can be effective in grouping elements together. The triangle shape is a good way to group three important elements and subconsciously suggests strength to the audience. A circular shape holds the viewers' attention as they gaze around the shape without actually leaving the frame, and encourages the audience to explore the composition. The cross is a powerful and quite symbolic form and, unlike other shapes, works well centered in the frame. It is crucial that all the elements of the composition have a balanced state of equilibrium. An unbalanced image will not "look right."

♦ FOCUSING ATTENTION
The story in this scene is talking about the banana, so to attract the audience's attention the banana is being waved about the lower right power point. Movement is a very powerful composition technique in its own right, and if that was not enough, the gaze of the character on the left is looking right at the banana too.

Aspect ratios
Depending on what your final delivery format is, you will need to adjust your shot design to match. For television you will probably work in either 4:3 or 16:9, whereas a feature film will be 1:85:1. New digital formats may vary, but always check before you start work. There are templates for these aspect ratios in the storyboard section on page 29.

♦ From a compositional point of view this is very dull. The centered tree is on a horizon line that splits the screen exactly in half.

♦ A simple adjustment, applying the basic rule of thirds, already makes a much more interesting composition.

♦ The lines of the path guide our eyes into this composition, leading us to the figure standing on a power point. To balance the composition a tree is placed on the left power point.

Post-production

Post-production is the important creative process that takes place after the production work has been completed, where the animation and sound are brought together. Visual effects, sound mixing, compositing, and editing are all part of this process and are not just technical tasks; they require a high level of creativity and skill.

See also: Rendering and output page 110, Editing animation: theory page 128

Compositing for animation

Compositing is where the final shots are put together and the magic is created.

Compositing for animation is becoming an increasingly important and creative part of the production process, with a different skill set required from that of compositors working primarily with live action. Live-action compositing involves a great deal of footage salvage such as fixing lighting and color inconsistencies, or removing unwanted objects such as pylons from a period drama. Animation, on the other hand, rarely has footage that needs fixing (with color correction being the possible exception), so compositing is more of a creative pursuit, and entire shots can be built up from scratch.

The creative significance of compositing in contemporary animation has totally blurred the boundaries, not only of the difference between 2D and 3D animation, but between animation and live action. The possibilities of mixing animation styles and techniques with live action are now limitless.

The digital image is made up of tiny squares of color, called "picture elements," or by the more common abbreviation, pixels. If your image is 1920 x 1080 (a high-definition TV image) it will consist of a grid of pixels 1920 wide and 1080 tall. This array of pixels, each with its own unique grid coordinate and single color, gives the illusion of a smooth and complete image when viewed from a distance.

Compositing is effectively having complete control over these pixels, and there are several types of programs that will do the job. If you are familiar with layer-based image manipulation programs such as Photoshop, then just think of compositing as exactly that, except that it involves moving images.

There are essentially two types of compositing programs—node-based and layer-based—both of which offer similar functions and capabilities, the only difference being the interface and workflow. Node-based compositors such as Nuke were originally designed and developed to composite complex visual effects and CGI and present the information in clear network maps, with each effect or function represented by a small box or label. Layer-based compositors such as After Effects, which were designed originally as motion graphics programs, present the information on a linear timeline and place more emphasis on the timing of each shot element.

⬩ RIG REMOVAL
This is a very common use of compositing software in stop-frame animation. This process is simple but time consuming, as it needs to be repeated for every frame where a rig can be seen in shot.

1 The original image shot by the animator is passed to the compositor for final cleanup.

2 When removing rigs, remember to shoot one clean frame of the background.

3 Working with a digital cutting tool, the rig is removed from the image, creating a hole.

4 When laid over the clean background plate, the final frame shows no sign of the rig.

Effects properties box where the intensity and strength of the effects can be adjusted.

Composition window showing the output of the project you are working on.

Effects menu box that displays the number of effects available.

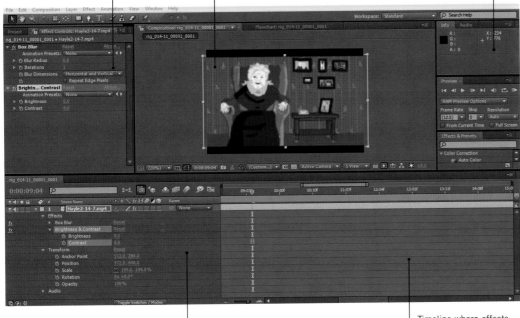

◊ LAYER-BASED PROGRAM

This type of compositing software displays the elements of animation in layers on a timeline. This type of program is ideal for animation and motion graphics.

Layer window displaying each clip and the effects associated with them.

Timeline where effects can be animated over a specified number of frames.

Typical uses of compositing

The typical uses of compositing in everyday animation studios are:

Rig removal

Stop-frame animation will use rigs to suspend puppets and objects in midair, and these rigs need to be cleaned out of every shot.

Color correction

Rendered images may have a strange hue, may be too dark, or may not match the renders from another studio or machine. These can be corrected in the compositor.

Mix and match

With compositing it is possible to mix all kinds of different animation styles and match them into a seamless image. You may have a CGI character on a 2D background or a stop-motion character in a CGI environment.

Atmosphere

Mist, fog, rain, wind, or just simple lighting can be added or adjusted in compositing. Additional lighting effects such as neon signs and water reflections are also possible.

Motion blur

For fast movements, the image elements can be blurred directionally, giving an effective motion blur.

▸ PIXELS

Compositing programs are powerful packages that can manipulate moving images frame by frame.

A digital image is made up of thousands of picture elements (shortened to "pixels") which cannot be seen from a distance.

Enlarging a digital image will create jagged edges as the pixels become visible, reducing the quality.

Each pixel has a unique "grid reference" position and one unique color. By manipulating these pixels within a bitmap, you can create all kinds of effects.

See also: Visual effects page 122, Editing animation: theory page 128

Compositing CGI

The type of render you choose depends on what you want to do with the shot. There are two types of composites that can be rendered by 3D programs: basic and multipass composites.

A basic composite is made up of three layers: the background, the object, and a matte. A matte is generated by the computer as an alpha channel of the object as you render the sequence, and isolates the exact area of the image in clear black and white. The compositing program recognizes the matte, knows that that area is "reserved" for the object, and cuts a hole in the background layer so that the object can sit neatly over the hole. It is possible to composite an object onto a background without a matte, but it will look slightly washed out.

For intricate shots a multipass composite is rendered out and involves any number of passes, depending on the complexity of the shot. It is not uncommon for one or two lighting passes, a shadow pass, and a reflection pass to be rendered. These can then be individually controlled and manipulated by the compositor.

Providing the 3D animation has been rendered out appropriately for the compositing that is required for the shot, you have enormous control over the final look of the image.

You might be surprised by how much 2D imagery is composited in "3D" animation. Whenever you see big landscapes or cityscapes they are nearly always 2D matte paintings carefully composited in with the rest of the CGI imagery to give the illusion of an entire 3D set. Compositors are able to work with multiplane layers, making it impossible to distinguish between what is 3D and what is 2D in the final composite.

► RENDERING IN LAYERS AND PASSES

As well as rendering out your scene as a complete image, it is also possible to render out in layers, which for example would separate the characters from the background and props, or more commonly in professional studios, as passes, whereby each attribute of the artwork is rendered separately to be combined in compositing. A complex image such as this frame from TheTale of Despereaux would be composited by a number of separate lighting and color passes.

► MULTIPASS RENDERS

A multipass composite can be made up of any number of render passes, but the basic passes are the occlusion pass, the depth pass, the diffuse pass, the shadow pass, the specular pass, and the beauty pass.

Particle systems

An expanding area of technology and innovation that bridges both CGI and compositing is the development of particle systems, which have developed to simulate natural movement. Each "particle" has its own behavioral parameters and is computer generated by an emitter that simulates a certain motion such as smoke, fire, hair, grass, water, or even crowds of people. As they are computer generated, particles can simulate movement that would be tediously impossible for an animator... Would you animate every shoot of grass in a field? Many of these particle systems are available in compositing software as standard or as optional plug-ins.

OCCLUSION PASS

This pass shows the scene lit by a white light with no color or textural attributes, which gives the scene its 3D form by revealing areas of shadow.

DEPTH PASS

A depth pass stores information about distance from the camera, which enables the compositor to adjust depth of field.

DIFFUSE PASS WITH NO SHADOW

A diffuse pass is the full-color rendering of the shot, which includes the diffuse illumination and color maps, but with no shadows.

SHADOW PASS

The shadow pass shows the position of the shadows on the objects. This will often just be black shadows on a white background, but here the objects have been left in for the illustration.

SPECULAR PASS WITH NO SHADOWS

This pass will isolate the highlights from your objects, showing anything else in the shot black. This is sometimes called a highlight pass.

MASTER BEAUTY PASS

A beauty pass is the main full-color rendering, which may include diffuse illumination, reflections, highlights, and shadows.

CGI tips

• It is possible to render out composites with blurs, but this means you are stuck with that blur, and as clever as compositing software is, removing a blur is a very difficult, if not impossible, task. Always render out clean and sharp.

CHAPTER 3
Post-production

Visual effects

The boundaries between animation and live action are narrowing all the time, and a visual effect isn't always what it seems.

Although this book is about digital animation, it is sometimes difficult to draw a line between where animation ends and live action starts. Visual effects sit exactly on the border, as the definitions of animation begin to blur. One definition, "the frame by frame manipulation of images," would now include most Hollywood movies.

Definitions aside, visual effects are a growing part of the film industry and many digital animation students aspire to a career in effects, so it is important to understand how compositing software can create some of the most amazing effects for live-action filmmakers.

"Visual effects" don't necessarily mean explosions, which is what most people think visual effects are; they are about shots that you take for granted, and usually don't even register as an effect due to the skill of the compositor.

The weather, for example, is often an effect. Not necessarily extreme weather either; even just regular rain or snow is usually created by a compositor. If you

do want extreme weather, however, not only would it be difficult, dangerous, and expensive to shoot in adverse weather conditions but it would also be impossible to predict the exact conditions you require.

Crowd duplication is another very common example of the hidden talents of a compositor. If you want to have a massive army of Roman soldiers you can hire 80,000 actors in full costume or get 80 and a good compositor. There are two ways to composite a crowd scene. You can sample a section of the crowd and then use a procedural compositing technique that allows you to effectively copy and paste the same actors around the shot, or do it directly by filming the actors in different areas of the shot and lifting the crowd from each shot and placing it on a master composite.

Set extensions, often used for adding parts of a set digitally, are commonplace. If you want two characters to fight on top of a building in front of the Eiffel Tower, instead of going to Paris to find the perfect rooftop,

▾ GREENSCREEN COMPOSITING
Powerful compositing tools now allow filmmakers and animators to combine live action with animation. Shooting an actor in front of a green screen lets the compositor place that actor in any location or situation. The background can be 3D or a 2D matte painting, depending on the camera move.

▴ GREENSCREEN
The actor is filmed against a flat color, usually green though any color will work, providing it does not appear anywhere else in the shot.

▴ 3D MODELS
The green color is removed from the picture and the subject placed into a 3D environment where the camera moves can be matched.

▴ ROUGH COMPOSITE
With the camera positions and movements working, the compositor can then begin to match the lighting. Without shadows and lighting the composite still looks fake.

▴ FINAL COMPOSITE
With shadows and lighting matching, the live action sits convincingly on the 3D background and to the audience will appear "real."

➤ DIGITAL SET EXTENSION

You may have a building in mind that would be perfect for your film, but the location may be wrong. Many movies use digital artists and compositors to create set extensions, where part of the set is real, and part is virtual. The composite shown here includes fog which has been added on by the compositor.

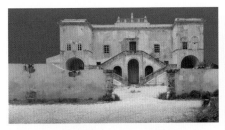

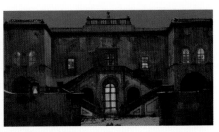

First the compositor must remove the sky and any objects such as modern buildings from the shot. The wall on the left has been extended and painted.

The colors can then be adjusted for night, and windows are added and lights painted inside them.

which probably doesn't exist anyway, you can shoot the action on any rooftop in town, then hand the footage to a studio to create the Parisian skyline as a matte painting and some nearby buildings in CGI which can then be composited into the final shot. You could even have a camera move in the footage, which could then be matched by the CGI artist and the compositor. Matching light and colors is particularly crucial when compositing live action and CGI together.

Greenscreen compositing is becoming increasingly popular with filmmakers, and with digital compositing becoming so believable it is now possible to shoot an entire film in a greenscreen studio and digitally composite the environment around the actors, regardless of whether that environment is Mexico City, the Congo jungle, or the moon. Many of these techniques are explained in the DVD extras of effects-heavy movies such as *The Bourne Ultimatum*.

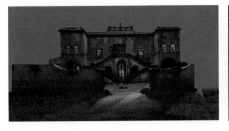

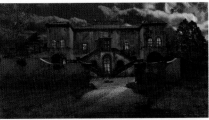

Further set extension is created by removing the gravel and replacing it with grass, creating a driveway leading up to the house.

A dramatic sky and moon is then added and the lighting is adjusted accordingly. Also further trees and details are added in the background and foreground to complete the shot.

Fact

One of the forefathers of special effects was George Méliès, who was working in Paris in the early part of the twentieth century. He had been working as a magician and started to use film to show tricks to the audience, such as people shrinking or disappearing. The effects got more and more sophisticated until they were fantastical stories such as his most famous film, *A Trip to the Moon* (1902).

➤ MULTIPLANE LAYERS

To allow the shot to appear three-dimensional, compositors will always layer their artwork in layers (often referred to as "two-and-a-half D") so that any camera moves will appear to be three-dimensional.

CHAPTER 3
Post-production

Sound production

Without sound, a moving image medium is dead, and as animation has no default sound (unlike video footage), everything has to be created from scratch.

When you "watch" a film, you do of course also "hear" it, and the sound contributes 50 percent of your experience. Overlooking or underestimating the importance of sound is the biggest mistake of amateur animators.

The soundtrack is made up of three key elements: the dialog, which is normally recorded and edited at the beginning of the production, the sound effects, and the music.

The music provides a device to exemplify the mood of the animation, often tapping into the potential emotion of the individual scenes and as a story. There are a number of options for the music; ideally, you should use original music for the animation, avoiding expensive copyright issues, and to make your animation unique. You can use existing recorded music, but as well as the expensive rights issues, music is very personal and people associate certain well-known tunes with emotional events in their own lives. Or you can use music libraries, which provide royalty-free music for a fee.

Sound design

Sound design is the creative composition of all sound except scored music and dialog. Start working on your sound design as early as possible in the production by recording ambience and sounds that could provide an interesting atmosphere or narrative device. The scratch track is a very rough assembly of sound that accompanies the animatic, often created with rough recordings—sound effects from CDs or the Internet that are never intended for the final mix, but are used to help build up the sound design.

Foley

This is the process of recording sounds that will become effects for particular actions and is named after the early film sound pioneer Jack Foley. Because

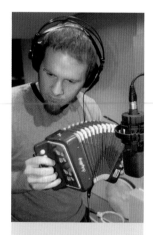

◖ TRY ANYTHING
When recorded and placed with an image out of context, sounds can be given a new life and a new identity. You will be surprised at what works. This broken squeezy box made a brilliant sound effect for a heavy-breathing dragon.

► SOFTWARE
Sound is also digital and can be created and mixed in programs such as Pro Tools. These applications are highly complex and will take time to learn, but once mastered will allow you to create music and multifaceted soundtracks.

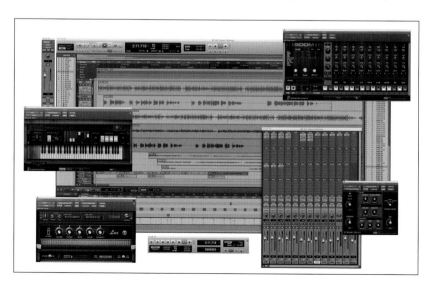

Assignment

Sound is an incredibly powerful medium for creating images in our minds, so without using any dialog or music create a two-minute story using nothing more than sound. Your soundscape can be recordings you have collected yourself or found online, but pay particular attention to the details, such as place (city or rural), time (night or day), and general ambiance, and see if you can build up a "picture."

→ FOLEY ARTIST
A Foley artist at work in the studio, creating sound effects for a cartoon show. Good Foley recording is essential for an original soundtrack, as each sound you create will be original and unique. Notice the selection of interesting objects to create sounds with.

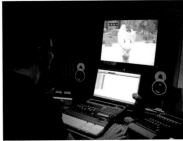

↓ CREATING A TRACKLAY
The sound designer will bring together the three elements of a soundtrack—the dialog, sound effects, and music— and create a soundscape for the animation. Using sound software to create a tracklay, the sound designer synchronizes all the sound to the picture, which has been fully edited and locked.

animation often features fictitious characters, places, or things whose sounds most of us wouldn't know about anyway, such as a dinosaur, the Foley artist has to create the sounds using everyday found objects.

Tracklay

Although the sound design can commence early in the process, the actual compiling of the soundtrack begins once you have a rough cut and the animation is finished. A sound designer will need to take cues from the action, and many of these will be frame-accurate, so the sound cannot be assembled correctly until the picture has been locked. Sounds can be laid into tracks and assembled in the correct place, synchronizing with the animation, in a process called the "tracklay."

Flap two pieces of bamboo in front of a microphone for a bird in flight.

Dip a piece of wood into a bucket of water and splash for a rowboat.

Rub two blocks of wood with sandpaper together for a good steam engine.

↓ FOLEY SOUND EFFECTS
To create interesting and effective Foley sound effects use your imagination and don't be too literal. You should experiment and see what works.

Sound production tips

- Never use sound effects from free websites; they are always heavily compressed and will create a hiss if played on decent sound equipment.
- Be creative. Don't be too literal with your sound.
- Use the best microphones and recording software possible. Bad sound will ruin your film.

Sound post-production

The bringing together of the sound elements and combining them with the images is one of the final tasks of the production. Like the picture, sound also requires editing before being mixed and dubbed onto the completed animation.

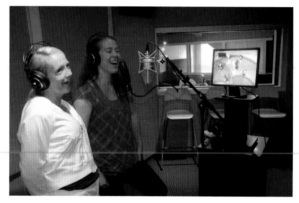

Voice artists recording voices to the finished animation—post-synch dialog recording or ADR (Automated Dialog Replacement).

◄ USING A SOUND STUDIO
Don't compromise your animation by having a less-than-perfect soundtrack. You need expertise and the best equipment possible. A professional production will use a professional sound studio for the final mix and dub, as they will have the expertise and special equipment designed for sound editing. Studios such as Supersonics Productions in Toronto specialize in sound design for animation, and have a creative and experienced sound-design team.

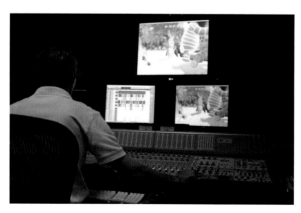

A sound engineer puts the finishing touches to a final mix.

Sound editing

The first sound editing of a production takes place before the animation starts, and this is the cleaning up and editing of the voice recordings. In the voice edit, you need to remove all the outtakes and any distracting noises and pauses, and make sure the timing of the voice is as good as possible. These edits are what the animators will have used for their performances.

The sound edit requires a final cut of the finished animation so you can accurately synchronize the dialog, music, and effects to the picture. At this point you do not need to worry about the mix, concentrating on building up the sound into the tracks in your sound-editing program. To make things easier in the long run the music, effects, and dialog should always be kept on separate tracks.

There may be occasions when the dialog is not acceptable for either a technical or creative reason, and the voice artists will be invited back for an ADR session to post-synch some of the dialog, in other words to re-record their lines to the finished animation. (See above left.)

The mix

This is where the sound really starts to come together and the world you have created in sound takes shape. The purpose of the mix is to make sure the sound is clear and nothing "battles" to be heard. The dialog should be given priority, as you do not want muffled voices, and the music and effects should be there but not overpowering. There may be occasions when an effect needs to be applied to a voice, such as an echo or reverb if the character is in a large space. You may also use stereo pans as actions work across the screen and emphasize out-of-shot sounds.

➜ SOUND QUALITY
In a professional studio a digital mixing console will control the output dynamics of the audio signals to a final high-quality master ready to be dubbed onto the picture.

FACT

The first totally post-produced synchronized sound animation was Disney's *Steamboat Willie* in 1928.

The dub or mix-down

Having listened through your final mix with the picture a few times just to make sure there are no final tweaks, it is time for the final dub. The dub combines the sound with the picture into one master digital format ready for showing and distributing. A finished animation will have a mixed-down composite of the soundtrack, but your master copy must keep the three elements separate: the dialog for when your film needs to be dubbed into another language, and the music just in case there are any future disputes over the copyright, in which case you can simply replace it.

Sound post-production tips

• You may have the best top-range speakers available in the sound studio, but always listen to your final mix on the cheapest speakers available too, as this is how some people will watch your film. If anything is not clear, adjust it.

• Never have space in the film where there is no sound. Even when there is silence, there should always be some kind of ambience.

• Don't make your soundtrack too busy.

• Overlap sounds. Having the sound start for a shot before you see it is an effective technique.

• Never use music without permission of the copyright holder.

◢ MUSIC
Creating your own music is the best option, but there are plenty of online music libraries that will sell royalty-free music for use on your production. Unless you have permission from the music publisher, never use music from an established recording artist.

➜ TEST THE SOUND
As well as testing your final sound on top-range speakers, don't forget that your audience may be watching your work on an old computer or TV, so check that your sound is clear on all types of speakers.

See also: The storyboard page 24, Sound production page 124

CHAPTER 3
Post-production

Editing animation: theory

Giving the animation pace, rhythm, structure, and flow is part of the editing process. Without good editing, an animated film is not finished.

Editing is a creative, specialized skill that can make or break a film. It is not just a case of cutting out mistakes, it is a creative process that bonds the story together into a cohesive, powerful, and fluid animated film.

Editing starts with the animatic, and by structuring, restructuring, and restructuring again, the early form of the film will begin to take shape. Once the final animation is complete, the editor can revisit all the footage and will often restructure sequences, cutting out shots here and replacing them there until the film is as strong and fluid as possible.

To edit animation you have to have a very strong visual eye and a knack for visual storytelling. Editing is all about the juxtaposition of images, how the meaning of one shot will be affected by the content of the following shot.

❙ *FLOW*

A well-edited sequence of animation should read well, keeping the eye directions consistent and the shots varied. The editing should keep the pace, flow, and timing of the animation alive as well as the story.

1

2

3

4

5

6

❙ *HOW EDITING CHANGES NARRATIVE*

The audience will always read a story into the way you order shots, and it is possible to completely change the way the story reads with a simple re-structure. The six images here tell completely different stories when placed in different sequences.

In this sequence, the story seems to suggest that two suspicious figures—one a hit man— arrange to meet at a quiet location to organize a deal. The final frame shows a graveside, suggesting the grizzly deal has been done.

1

With exactly the same images but in a different order, this story seems less malicious. Starting with the image of the graveside and church, the man then makes a call and drives to meet the woman, perhaps just to collect his wages after some maintenance work on the church and grounds?

6

With the frames reordered once again, another story emerges. This time it reads as if the man has been called by the woman to come to the church at night, in order to comfort her, perhaps after a recent bereavement.

1

Editing tips

- Get the opinion of a professional editor if you cut your own film. An external pair of eyes will be much more ruthless than you, and they may suggest cutting out the shot that took you three weeks to animate, but if it works for the film as a whole, take their advice.

- Don't be precious about shots. If they don't work, cut them.

- Don't be afraid to completely restructure the whole film. There is always a better way to tell the story.

- Don't try to do trendy editing techniques until you are comfortable with the basics. You risk ending up with a self-indulgent and obscure film if you do.

- Avoid trimming all the action so tight that there is no room for the shots to breathe; sometimes pauses work.

- Don't overuse transitions. They can be annoying, and you will need a very good reason to use one of the transition effects offered with nearly all editing programs, which can look amateur and corny.

◖ CONNOTATION

Placing a shot of a firefighter holding a baby after a weeping woman affects our emotional understanding of the images and suggests a story.

◖ JUXTAPOSITION

Juxtaposing images to reinforce a story is part of the skill of an editor. The fighting bulls have nothing to do with the men shouting, but their juxtaposition could add poignancy to a scene.

Key points for editing

When editing animation there are some key points to be aware of in constructing a scene.

Emotion

Unless the audience cares for the characters they won't care for the film. Use visual storytelling to make sure the emotion of a scene is as strong as possible.

Story

Every scene in your film should have a reason or move the story on. If nothing has been revealed, resolved, or obstructed, then cut it.

Rhythm

Editing is like being a superstar DJ: You want your audience to be taken on a journey, building up the pace in places where there is high tension and drama, and slowing it down for the more gentle parts. If a film's rhythm seems stilted in its editing, feels too slow or fast, it's not working.

Continuity

Probably the biggest stumbling block for animators is continuity. If the film doesn't flow and make sense, the audience will switch off. Check that every single cut makes total sense.

Sound

Don't forget to leave space for the sound to carry some of the story. Sound is a powerful tool in editing.

Transitions

Rather than a hard cut from one shot to the next, you may decide to use a transition, which could be a dissolve from one shot to the next; a fade, which normally fades from and to a color; a wipe, which looks like a car windshield wiper; or something like a page-turn effect. Be very careful when using transitions, as they do have storytelling connotations. A dissolve, for example, normally signifies a short shift in time like "later that day," while a fade indicates a longer shift in time like "the following day" and a ripple dissolve might indicate a dream.

 3
 4
 5
 6

 1
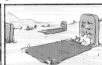 2
 4
 5

3 6 5 4

Editing animation: practice

The process of editing is not just a technical process; it is a very important creative process too.

Digital editing is fast and easy, with many editing packages available to the amateur and professional animator. The previous two pages touched on some editing theory; here we look at the editing process.

The animatic

The animatic is the storyboard presented on a timeline to finalize timings and scene structures. For editing purposes, however, it is far more than that. An animatic is the time and place to really experiment with the film's structure, which must be correct before the animation starts. An animatic can be created in an editing program such as Final Cut, Premiere, or Movie Maker, and there are a number of packages available designed specifically for this such as ToonBoom Storyboard Pro.

Rough cut

As the animation comes off the production line, the editor can insert these finished scenes into the animatic and build up the rough cut. This rough edit is an organic assembly of all the material as the film takes shape, including the picture and sound (at this point the sound will be incomplete but the editor can use whatever is available), and the editing process begins to piece together sections of the film. Once all the animation is finished, the editing process proceeds to the next level, and the editor can begin to work on ways to improve the structure and flow. This may involve creating a number of different rough cuts, until the final cut begins to crystallize.

Final cut

The final cut is the edited version of the animation that everyone is happy with, including the producer and the director, and once signed off, creatively the picture is locked. Locking the picture means that no further changes to the edit can be made, and the edit is passed to the sound designer and musician, who can create and synchronize anything they need to add to the picture.

Clocks, bars, and tone

A professional production will normally involve both offline editing and online editing. Offline editing is the day-to-day work done by the editor as the production comes together. The online edit is a technical process, often done at a professional post-production house that "conforms" all the final images together using an electronic edit list (EDL) of all the elements and their

♦ BUDGET SOFTWARE

You do not need expensive editing software to edit animation, and even free programs such as Windows' Movie Maker or the Mac's iMovie do a great job at cutting together your film. They will even give you a range of transitions, effects, and titles to use. The layout of Movie Maker is not dissimilar to Premiere or Final Cut Pro.

Preview window

Output window

Transitions

Video timeline

Audio timeline

Preview window

Final output window

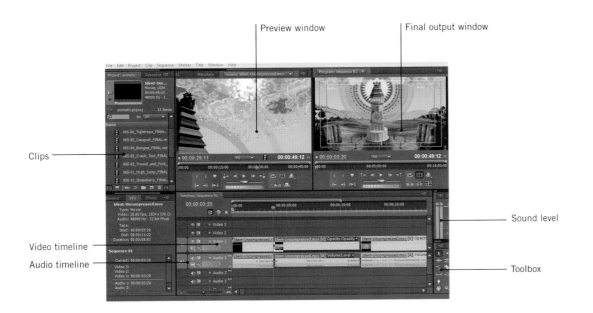

Clips

Video timeline

Audio timeline

Sound level

Toolbox

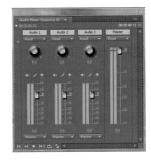

⬥ SCRATCH TRACKS

As well as the picture, editing programs manipulate sound, and although they are not designed to mix your final sound, they are fantastic for creating rough tracklays and scratch tracks.

properties used in the production. In addition to a technical check of the footage the online editor will add color bars and a sound tone at the front of the film, so the colors and audio levels can be calibrated on other final viewing equipment, and a clock, which not only counts down to the start of the film, but assigns an "ident" (identification) to the production, giving a date, production number, title, and names of key personnel involved in the production.

CODECs

When making a final output of your finished film, you will want to make several versions in different formats. Your master version should always be backed up as a TIFF image sequence, but for online distribution, for example, you will need to make a smaller, lower-quality version. For this purpose you will need a compression/decompression (CODEC) piece of software that will compress your film into a size that can be uploaded to a website.

⬥ PROFESSIONAL SOFTWARE

Most editing programs have a similar interface. There is normally an area to store the various clips that make up the movie, a final output window for reviewing the edit, a timeline where you can trim shots and adjust the audio, and a toolbox for manipulating the images. This screengrab is from Adobe Premiere CS4.

⬥ COLOR BARS

In order to calibrate final viewing equipment, you should always add thirty seconds of color bars at the front of your production. This will ensure that your film will be shown at the optimum picture quality.

Editing tips

- Never compromise on the edit of your animatic. If a film is not working at this stage, it will be very difficult to make it work later on.

- Make as many rough cuts as possible to explore all the alternatives of structure, and experiment. With digital editing it is so quick and easy to try things out.

- Use an established CODEC, as it will work only if the viewer also has that CODEC on their machine. Just because you have the latest gizmos does not mean everyone else does.

MIRAGE

MENU:
about
characters
download
credits
contact

WATCH MOVIE:
original: **HD720**
medium: 720X405
small: 480X270

RENDER 3D5 PRESENT FILM SHORT "MIRAGE" MADE BY: JAKUB BOŚ, ARTUR MARCOL, KRZYSZTOF KROK.
VOICE: GIORGIO: ARTUR MARCOL REGINA: GAIL THEOBALD, DOG: BEN DENNET, FAKHIR: JAMES COLES, AQIL: ANDY WYATT
SPECIAL THANKS TO: ANDY WYATT & MARCIN KLUSEK

Professional practice

In all its various forms the global animation industry is worth billions, and to get noticed you will need to promote yourself and your work. This can be extremely daunting, but if you do your research and present yourself well, you should soon be able to make the contacts you need.

See also: Selling page 136

Promotion

Big studios spend millions on publicizing their movies, but you can do the necessary publicity on a budget.

► **PUBLICITY STILLS**
These publicity stills both feature not only a final image, but the title of the film complete with its own logo and a website address; anyone interested can find out more about the film by looking up the link.

Publicity stills

To publicize a film you are going to need some high-resolution still images of at least 300dpi to send to the print media. Framegrabs from the film will not be high enough quality, and even high-definition images will be only 1080 x 720 pixels, which has a maximum print size of 3.6 inches (9 cm) wide. You should therefore render out some high-resolution images from the compositor at the same time as rendering the film. For your stills, choose some of the most striking images; you may want to create some especially for promotion. Don't forget to make some portrait-formatted images too, as they often fit better into magazines.

Making copies

Fortunately it is now very easy to distribute films electronically and most festivals and online broadcasters will accept digital copies of your film. These can be uploaded via an FTP site or through a website offering large file transfers. Never e-mail your actual film file to anyone; it will clog up their inbox and you won't be very popular. If you want to e-mail your film to someone, upload it to somewhere specific, such as a blog, and e-mail them the link. Some people still prefer to receive DVDs, so get some professionally made with a well-designed presentation cover. First impressions count.

Digital distribution

There are two reasons to distribute animation online. One is to get a name and establish an online presence or fan base, which will be attractive to potential investors in your work. The other reason is to make direct financial gain, and there are certain media operators such as phone companies and web broadcasters who will pay for content. Just be aware that the more places you upload your work to for free, the more people will see it, which is great, but this will also reduce the value of the work, and online channels

will be less keen to pay for a film that is not exclusive to them. Plan a strategy on how you want to distribute your work, which could include just uploading short clips or teasers.

Publicity and marketing

Big animated movies often spend anywhere between 10 and 50 percent of the budget on the marketing, and when you consider that a modest animated feature can cost in excess of $100 million, this means big bucks. The film marketers will plaster billboards, newspapers, and magazines; they will get television and radio interviews with the stars and take out television, radio, and online advertising spots; and they will produce trailers or even arrange a tie-in with a well-known product or restaurant chain.

If you have produced an independent animation, you are probably not going to have millions to spend on publicity, but it can be done on a budget. Design a dynamic website that gives information about you and the film, with images and perhaps clips of the animation. Send information about your film to all the magazines, newspapers, and online journals you would like to feature your work. Don't just choose the animation publications; if your film is about fish, why not send it to all the fishing or aquarium magazines? Be as creative with the marketing and publicity as you can. Remember the old saying: "There is no such thing as bad publicity"!

Festivals

There are some important and prestigious festivals that show contemporary animation attended by executives and content buyers looking for the latest "big thing." A few are competitive, offering substantial prizes for the winners. These festivals are also excellent places to network and meet people from the animation world.

♦ FESTIVALS
The Ottawa International Animation Festival is one of the largest and most established animation festivals in the world and awards prestigious prizes for the best animated films. A list of festivals can be found in the Resources section on page 141.

◄ DIGITAL DISTRIBUTION
There is a growing number of online web channels that specialize in animation, and some will pay for content. These offer a great way for your work to be seen by a global audience and will often award cash prizes to the most voted-for animations.

See also: Promotion page 134

Selling yourself

Promotion

▶Selling yourself

You may be extremely talented, but unless people find out about you, they won't know that. Very few opportunities are advertised, and it is up to you to get noticed.

Business card Your first weapon as part of your animation arsenal is a business card. Don't be too flashy; just use a simple, regular-sized card with your name, what you do, your website, and your contact details. You will find this useful when meeting people. It looks professional and your details will be kept.

Resumé An up-to-date resumé is next on your list. Remember to include all the skills you have, and don't forget to include personal achievements and interests. Organizing a climb to the top of Everest, for example, does not have anything to do with animation, but it shows you have stamina and team skills, both of which are required for a job in animation. Always start the resumé with your most recent and main skills and never, ever lie. The animation industry is small enough for you to be found out!

Trade press When looking for work, keep an eye on the trade press to find out what is in production and who is producing it. Become familiar with the industry in your area and attend local networking events. If you are a recent graduate or starting out, don't oversell yourself. Offer your services as a runner or assistant, as you will be quickly promoted if you prove to be reliable and a pleasant person to have around.

Portfolio/showreel It is important to have a good portfolio of work, but it is becoming more and more imperative to have an online version. An online portfolio or showreel can be updated regularly, and these days, pretty much everything is digital. Your portfolio/reel should have details of any animation work

Tips

- Get a clear, well-designed website made with good navigation and contact details.

- Promote your own strengths, perhaps with a specialty.

- Do your research and find out who is the best person in the company to approach.

- Present yourself as a professional. Check spelling in any correspondence and check that any digital files you send work on any machine.

- Put only work you are proud of on your portfolio/reel.

- Learn to network.

- Be persistent (but don't overstep the mark; see below) and don't be disheartened by rejection letters.

- Don't stalk potential employers; you don't want to appear desperate (or weird). Learn to take no for an answer.

- Never say no!

♥ *WEBSITE*
Create an appropriate website to help with the promotion of your work. As well as clips and downloads, this is a great platform to show off your skills and give information about the animation and the team that created it.

♥ *DVD*
First impressions count, so if you want to send a DVD copy of your work to someone, design a professional looking cover and label for the disk. Check the spelling and double check the DVD works before sending out.

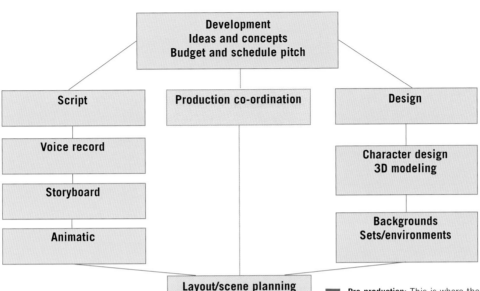

► PIPELINE
A digital animation studio will employ artists with special skills in particular areas of production. The "pipeline" shown here is a basic but typical workflow for a studio showing the types of roles required for a crew.

Pre-production: This is where the ideas and designs are generated, and artists who work in pre-production are highly creative "ideas" people; visualizers with excellent drawing and design skills, writers, storyboard artists, and modelers.

Production co-ordination:
The producer is the overall boss of any production. Depending on the size of the production, the producer may be assisted by a team of co-ordinators ensuring each part of the pipeline is kept on target. The director will work closely with the producer.

you have been involved with, including a breakdown of what your contribution was.

Focus on your specialty If for example you are a character designer, showcase your skills by having not only final designs but also concept sketches, life drawings, and observational studies. A showreel is also important. This should be a short, punchy montage, often to uplifting music, showcasing your best pieces of work. This can be a series of models you have made, animation tests, clips of compositing or fully finished animation; whatever it is that shows you at your best. After the montage you can put a selection of longer clips, or ideally on a DVD create chapters for each clip.

Production: Bringing the designs and concepts to life is the job of the crew in production. The production team includes highly creative roles such as scene planners, animators, lighters, and compositors, and also skilled technical roles such as programmers and technical directors who will work out the best way to produce some of the visual effects, or develop special rendering methods.

Roles and jobs
This book has highlighted the process of creating an animation, indicating some of the areas in which you may find work. A large studio is likely to recruit people with specialized skills, whereas a small studio will often look for people who have a range of skills.

Post-production: The task of bringing the picture and sound together happens in "post." Editors and sound designers work together with the director to complete the film ready for delivery, when the film can finally be marketed and distributed.

Glossary

Animatic: A filmed, taped, or computer-animated version of the storyboard that runs the same length as the finished animation.

Anime: A Japanese-style animation. Sometimes called Japanimation or manga, it is characterized by people with large, exaggerated round eyes.

Antialiasing: The process of resampling pixels to make hard, jagged edges look soft and smooth.

Background artist: The person who paints the background scenery of an animation.

Batch process: Setting the computer to perform a repetitive task to a large number of files; e.g., reducing all images to the same size.

Bitmap: A text character or graphic image made up of dots or pixels in a grid. Together, these pixels make up the image.

Block out: Used in the early stages of a 3D animation to place characters, props, and backgrounds in the correct position, with the camera moves.

Blue screen: A background of pure blue (or green) that can be removed with compositing software and replaced with another image. Also known as Chroma-Key.

Bones: Wireframe objects in animation software that are joined together to make a skeleton. The skeleton is attached to a character model; once this is done, the character model becomes the skin.

Broadband: A fast Internet connection. For home computer users, this is usually either DSL or cable.

Camera stand: A support for a still or video camera. This can be a tripod, a copy stand, or a more sophisticated professional rig.

CD, CD-R, CD-RW: Compact Disc, Compact Disc Recordable, Compact Disc Rewritable.

Cel: A sheet of transparent cellulose acetate used as a medium for painting animation frames. It is transparent so that it can be laid over other cels and/or a painted background, then photographed.

CGI (Computer Generated Imagery): Animated graphics produced by a computer. Also referred to as CG in the context of animation.

Character designer: Artist who creates the look of the individual characters.

Cleanup: Retracing an animator's sketches into single, clearly defined lines.

CMYK: Cyan, magenta, yellow, and black—the standard inks used in four-color printing.

CODEC: Compression decompression software that reduces the size of a movie file to be streamed online. The recipient viewer will need the player installed on their machine in order for the computer to decode and play the movie.

Compositing (also Comping): Joining together the various layers and elements of an animation or special effect.

Digital ink and paint: The process of tracing and coloring an animator's drawings using a computer.

Director: Creative supervisor for an entire animation who decides everything from camera angles to the musical score.

Dope sheet: see Exposure sheet.

Doubles: Shooting on doubles or twos is the process of photographing two frames of a single image, either as a cel or 3D model.

DV: Digital Video.

DV Camera: Digital Video Camera.

DVD (Digital Versatile Disc): A disk capable of holding a large amount of data. Principally used for films.

Dynamics: Simulation software that generated animation of natural motion such as fluids. Can also be used for simulating human motion and used for crowd shots.

Exposure sheet: A form onto which all the shooting and drawing information for an animation is entered, one frame at a time.

Field guide: A punched sheet of heavy acetate printed to indicate the sizes of all standard fields. When placed over an artwork, it indicates the area in which the action will take place.

Flash: A computer program by Adobe for creating vector-based animation.

Frame: An individual image as part of a sequence. When the sequence is played at speed, each frame is normally seen for 1/24 of a second, or at a frame rate of 24 fps. However, the fps varies according to format; e.g., Film—24 fps, PAL video—25 fps, NTSC video—29.97 or 30 fps.

GIF (Graphics Interchange Format): An image format used for images with fewer than 256 colors. Good for bold graphics.

Graphics tablet: A computer peripheral that allows you to draw or write using a penlike instrument as if you were working on paper.

Graticule: see Field guide.

Grayscale: Black-and-white image with full tonal range of grays.

HD: High-definition video of higher resolution than standard-definition (SD) video. The display resolutions of HD is 1280x720 pixels (720p) or 1920x1080 pixels (1080i/1080p).

Inking: Tracing a cleaned-up drawing onto the front of a cel for painting.

Jaggies: Hard-edged pixels that appear on computer-generated lines when they are not antialiased.

JavaScript: Platform-independent computer language developed by Sun Microsystems. Mostly used for adding interactive effects to web pages.

JPEG (Joint Photographic Experts Group): A format for storing digital image files so they take up less space.

Keyframe: Frame that shows the extreme of an action or a principal movement in an animation.

Layers: Cels composing different elements of a single frame and mounted one on top of the other. Also simulated in software programs.

Layout artist: The person who designs the composition of the shots.

Lead animator: Person in charge of the animation team; poses the keyframes.

Lightbox: A glass-topped box with a powerful light source. Used by animators to trace artwork.

Line test or pencil test: An animator's rough drawings digitized and watched back to test the animation timing before clean up or animating in 3D.

Lip-synch: The matching of characters' mouth shapes in time with recorded dialog.

Live action: Film made using real people or actors.

Maquette: A small statue of a character used as a drawing or 3D modeling aid.

Matte painter: a background artist who creates 2D images used as backdrops in a 3D scene.

Megapixel: 1,000 pixels. Used to describe the resolution of digital cameras.

MIDI (Musical Instrument Digital Interface): An industry standard for connecting synthesizers to computers in order to sequence and record them.

MoCap (Motion Capture): A way of capturing accurate human movement for use in 3D software by attaching sensors to an actor and mapping the coordinates in a computer program.

Model sheet: A reference sheet for the use of animators to ensure that a character has a consistent appearance throughout a film. It consists of a series of drawings showing how a character appears in relation to other characters and objects, with details of how it appears from various angles and with different expressions.

NTSC: Television and video format used in the U.S. and Canada.

Onion-skinning: The ability to see through to underlying layers of animation poses and comparing images.

OS (Operating System): The part of the computer that enables software to interface with computer hardware. Two commonly used operating systems are Microsoft Windows and MacOS.

PAL: Television and video format used in Europe, Australia, and Asia.

Panning shot: A shot that is achieved by following an action or scene with a moving camera from a fixed position.

Phoneme: Phonetic sounds used in speech to help the animator make the correct mouth shapes (visemes) for lip-synching.

Pixel (from PICture ELement): The smallest unit of a digital image. Mainly square in shape, a pixel is one of a multitude of squares of colored light that together form a photographic image.

Plug-in: A piece of software that adds extra features or functions to another program.

Pre-production: The planning stage of a film or animation before shooting begins.

Primitives: Basic shapes used by 3D software (cube, sphere, cylinder, cone).

QuickTime: A computer video format developed by Apple Computer.

QTVR (QuickTime Virtual Reality): A component of QuickTime, used for creating and viewing interactive 360-degree vistas on a computer and on the Web.

RAM (Random Access Memory): The area of computer memory where the computer holds data immediately before and after processing, and before the computation is "written" (or saved) to disk.

Raytracing: Used by a rendering engine to create an image by sending virtual rays of light from the light sources so they reflect off the objects in a scene.

Registration: The exact alignment of various levels of artwork in precise relation to each other.

Render: To create a 2D image or animation from 3D information.

RGB (Red, Green, Blue): The colors used in computer and T.V. monitors to make all the colors we see on screen.

Script (also Screenplay): The dialog and directions of a film.

Set extension: used in visual effects where a real set is extended digitally.

Showreel: A portfolio of moving images on videotape, DVD, or CD.

Stop frame or stop motion: Animation where a model is moved incrementally and photographed one frame at a time.

Story reel: see Animatic.

Storyboard: A series of small, consecutive drawings plotting key movements in an animation narrative, and accompanied by captionlike descriptions of the action and sound.

Streaming video: A sequence of moving images sent in compressed form over the Internet and displayed by the viewer as they arrive. The Internet user does not have to wait to download a large file before seeing the video.

Texture map: 2D image used to give texture to a 3D object.

Tiff: Tagged image file format. A lossless bitmap image file that is used for rendering.

Timeline: Part of software that displays the events and items of an animation in terms of time or frames.

Track (or truck): A cinematic shot where the camera moves through a scene.

Tweening: Drawing the intermediate drawings/frames that fall between the keyframes in an animation.

USB: A high-speed connector used to download digital data at extremely high speeds from peripherals (such as a digital camera, a hard drive, a scanner, or audio hardware) to a computer.

Vector: Lines created in computers using mathematical equations.

Vector animation: An animation that uses images created with vectors. Vector animations are resolution-independent, so they can be enlarged to any size without deterioration of image quality.

Vertex: A control point on a 3D object, where two lines of a wireframe model meet.

Visemes: Mouth shapes corresponding to phonemes.

Wireframe: A representation of a 3D object showing its structure made up of lines and vertices.

World Wide Web: The graphical interface of the Internet that is viewed on a computer using a software browser.

Resources

Magazines, journals, and websites
Animation Magazine
www.animationmagazine.net
Animation World Network (AWN)
www.awn.com
Imagine www.imagineanimation.net
FPS Magazine www.fpsmagazine.com
3D World www.3dworldmag.com

Materials and supplies
Chromacolour
www.chromacolour.co.uk/
www.chromacolour.com
Cartoon Supplies
www.cartoonsupplies.com
Paper People
www.paperpeople.co.uk

Software
Autodesk (makers of Maya, 3DS Max,
Mudbox, and Maya Composite)
www.autodesk.co.uk
http://usa.autodesk.com

Daz3D (free download for modeling and
animation)
www.daz3d.com

Toon Boom (makers of Storyboard Pro,
Animate, and Animate Pro)
www.toonboom.com

Adobe (makers of Flash, After Effects,
and Premiere)
www.adobe.com

Stop Motion Pro
www.stopmotionpro.com/

Digital animation courses
North America
Sheridan
www.sheridanc.on.ca

Vancouver Film School
www.vfs.com

California Institute of the Arts (Cal Arts)
Valencia, CA USA
www.calarts.edu

Savannah College of Art & Design
Savannah, GA USA
www.scad.edu

Ringling School of Art & Design
Sarasota, FL USA
www.ringling.edu

Rhode Island School of Design
www.risd.edu

Online
Animation Mentor
www.animationmentor.com

Festivals and conferences
Ottawa International Animation Festival
http://ottawa.awn.com/

Annecy International Animated Film
Festival and Market
www.annecy.org

Bradford Animation Festival
www.nationalmediamuseum.org.uk/baf/

London International Animation Festival
www.liaf.org.uk

Animated Exeter
www.animatedexeter.co.uk

Animex
http://animex.tees.ac.uk

Hiroshima Animation Festival
http://hiroanim.org/

FMX
www.fmx.de

Festival of International Animation
Stuttgart
www.itfs.de/en/

Holland Animated Film Festival
http://haff.awn.com/

World Festival of Animated Film Zagreb
www.animafest.hr/en

Siggraph
www.siggraph.org

Organizations
ASIFA The International Animation
Association
http://asifa.net/

Skillset
http://www.skillset.org/animation/

Index

Credits

Quarto would like to thank the following for kindly supplying images for inclusion in this book:

p.9 Claire Underwood/Pesky, p.10 Monica Kendall, p.11 Ian Friend, p.15tl Lumier Brothers, Wönky Films, p.18, 19bl, 19tr RKO / THE KOBAL COLLECTION, 20TH CENTURY FOX / THE KOBAL COLLECTION / GROENING, MATT, MTV/NICKELODEON / THE KOBAL COLLECTION, p.19tl Spore © 2009 Electronic Arts Inc. All Rights Reserved, p.20t © Hulton-Deutsch Collection/CORBIS, p20b REMY (Remy) RATATOUILLE, DISNEY/Allstar Collection, p.21, 41b, 57 Vincent Woodcock p.24, 41t, 42, 56 Claire Underwood/Pesky, p.28, 128 Chris Drew, p.30–31 Ooglies © MMIX, p.35t, p.40 Leigh trixibelle, 42tl&r Nafi Nizam, p.40bl Foo Foo © The Halas & Batchelor Collection Ltd, p.43b Manga Entertainment Ltd. All Rights Reserved. AKIRA © 1987, AKIRA Committee. Produced by AKIRA Committee/ Kodansha, p.46 2D and not 2D, Paul Driessen. Photo used with the permission of the National Film Board of Canada,p.49tl Len Lye, Film still from Colour Flight, 1938. Image Courtesy Len Lye Foundation, Govett-Brewster Art Gallery and the New Zealand Film Archive, p.49tr Norman McLaren, Photo used with permission of The National Film Board Canada, p.49b PARAMOUNT / THE KOBAL COLLECTION, p.50b, 51bl Linda McCarthy ©, p.51t Nexus Productions Limited, p.51br Tim Searle, Triffic Priductions © 2007 Triffic Films, p53tl © 2009 DECODE Entertainment Inc., p.55, 92–93 Monica Kendall, p.60 Pixel Pinkie © 2008 Film Finance Corporation Australia Ltd. Tasmania and Resources and Blue Rocket Productions Pty Limited, p.71 Nick Mackie, p.77tl METRO / THE KOBAL COLLECTION, p.77tr © Silver Fox Films/Classic Media, p.90 Muybridge/ Dover Publications, p.100–101, 113, 122–123 Ian Friend, p.108–109 Jay Clarke, p.120b ANTOINETTE, DESPEREAUX & LESTER, THE TALE OF DESPEREAUX, UNIVERSAL/Allstar Collection, p.125 Coral Mula, p134t BLUE SKY/20TH CENTURY FOX / THE KOBAL COLLECTION, p.135t Ottowa International Animation Festival © 2008, www.animationfestival.ca.

The author would like to send special thanks to all the artists who contributed artwork to this book, in particular Nick Mackie (www.shufti.co.uk) for allowing him to use one of his short films as a case study. He'd also like to thank Kathy Nicholls, Georg Finch, and Chris Harris at Supersonics Productions in Toronto (www.supersonicsprod.com), Alan Gilbey (www.alangilbey.com), Keith Wickham (www.keithwickham.com), and Mark Mason (www.markmasonanimation.co.uk).

Check out the author's own website on www.eggtoons.co.uk.

While every effort has been made to credit contributors, Quarto would like to apologize should there have been any omissions or errors, and would be pleased to make the appropriate correction for future editions of the book.